12 JUN 2021
17 APR 2023

FOY
9.8.13

KT-549-532

THE LONDON BOROUGH
www.bromley.gov.uk

Beckenham Library
020 8650 7292
Please return/renew this item
by the last date shown.
Books may also be renewed by
phone and Internet.

Bromley Libraries
30128 80071 431 6

MASTERING YOUR

DIGITAL SLR

HOW TO GET THE MOST OUT OF YOUR DIGITAL SLR

APPLE

This edition published in the UK in 2012 by
Apple Press
7 Greenland Street
London NW1 0ND
www.applepress.com

First published in 2005 by RotoVision SA
Updated in 2012 by Tony Seddon
Copyright © 2012 by RotoVision SA

10 9 8 7 6 5 4 3 2 1

All rights reserved. No part of this publication
may be reproduced, stored in a retrieval
system, or transmitted in any form or by
any means, electronic, mechanical,
photocopying, recording or otherwise,
without permission of the copyright holder.
While every effort has been made to
contact owners of copyright material
produced in this book, we have not always
been successful. In the event of a copyright
query, please contact the Publisher.

ISBN: 978 184543 473 1

Original design by James Emmerson
Art director for RotoVision Luke Herriott

Reprographics in Singapore
by ProVision Pte.
Tel: +65 6334 7720
Fax: +65 6334 7721

Printed in China by 1010 Printing
International Ltd.

MASTERING YOUR

DIGITAL SLR

HOW TO GET THE MOST OUT OF YOUR DIGITAL SLR

CHRIS WESTON

APPLE

CONTENTS

INTRODUCTION

When *Mastering Your Digital SLR* was first written, digital photography for the masses was still in its infancy. The split between those users shooting digitally compared to film was half at most, and many photographers were reluctant to accept digital capture as a legitimate photographic medium. How times change. Digital photography has now been embraced by all but the die-hard film user and Digital Single Lens Reflex (DSLR) cameras are the overwhelming preference for amateur and professional photographers alike.

In the years since the first digital camera appeared there have been many changes, although most have been evolutionary rather than revolutionary. Pixel count of sensors has increased so that mid-range DSLRs now have a resolution once afforded only to professional specification cameras. Viewing screens have become bigger, brighter, and better in quality. Self-cleaning sensors and anti-camera shake technology are more prevalent. 2008 also saw a massive leap forward for digital photography, with the introduction of the Nikon D3—a camera with 14-bit technology, vastly improved dynamic range, and a noise management system second to none. With such a leap forward, the D3 predicted the immediate future for DSLR cameras.

Despite all of these changes, one fundamental advantage of digital photography remains: the digital format has given control back to photographers.

Photography is, and has always been, a two-part process: image capture and image processing—what first takes place in the camera and what then happens in the darkroom. For confirmation of this assertion, you just have to look at the work and writings of luminaries such as Ansel Adams, who pioneered popular photographic processes and used creative darkroom techniques to overcome the limitations of film. Using a musical metaphor, Ansel Adams said, "The negative is the score, the print is the performance."

This two-part process creates a problem for many film-based photographers. In truth, how many people develop their own film and spend endless hours hand-printing the outcome? Most people send away film to a processing lab where the work is undertaken for them, and in doing so they abdicate part of the image-making process to a complete stranger who was neither at the scene when it was photographed, nor understands the emotional message the photographer was trying to portray. In film photography, we cede at least half of our control over image quality to someone else.

With digital capture, this no longer occurs. All the mastery we once relinquished is now back in our own hands, quite literally at our fingertips. Unlike a film camera, which has the sole purpose of recording an image, a digital camera will capture an image and apply a degree of image processing "in-house." Once the picture has been produced, it can be enhanced on the computer with the exact same techniques used by darkroom masters, but with an ease open to all, rather than to an elite few. And herein lies the real reason that digital technology has revolutionized photography. It has given to the masses the opportunity to express their creative mind and to delight in the full potential of the photographic art. Welcome to the digital world!

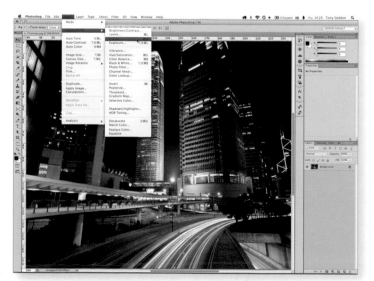

LEFT
Digital photography has brought traditional darkroom techniques to the fingertips of all through software applications such as Adobe Photoshop.

RIGHT
There are very few actions available to the digital photographer that would come as a surprise to film users experienced in wet darkroom techniques.

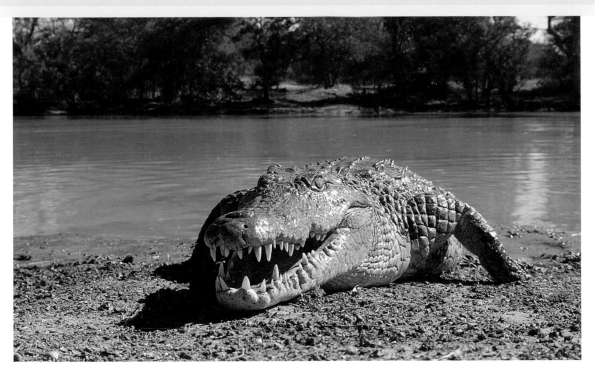

Only a handful of traditional diehards remain undecided about digital photography, and most have made the leap from film. A great many newcomers have also been introduced to photography for the first time because of digital technology, and the million dollar question for them is, how does one get the most out of a digital camera.

I first acquired a DSLR camera in April 2003. At the time, I was a skeptic, but, like many other professional photographers at the time, I felt I needed to understand the technology rather than dismiss it out of hand. I took the new camera with me on an assignment to South Africa, with the aim of testing it out against my film cameras when I had some free time. By day two of the trip it had become my main camera, not through necessity but simply because of the freedom it gave me to create images and the improvements it made to my workflow. I felt more comfortable experimenting with new techniques, and with the advantage of being able to review the results immediately,

I quickly found my productivity increasing. On top of that, by the time I returned the camera had more than paid for itself in the savings I had made on film and processing costs.

In practice, the differences between film and digital capture lie not in the camera so much as in the approach to photography. Of course, there are new disciplines to learn, but in so doing, you will find that you learn more about the science of photography in the process. Most of these changes I have had to learn the hard way, by trial and error, and continuous shooting in the field. In this book you will find the results of my efforts alongside the efforts of a selection of other photographers, plus answers to the frequently asked questions about the digital format. The solutions I give are based on firsthand encounters with everyday challenges that cover camera setup, photographic technique, field craft, and image processing. This book is produced from my field notes, and I hope that they are as useful to you as they were to me.

ABOVE
The digital format changes your approach to photography. This picture of a crocodile was made possible because of the immediacy of the medium. It's not a situation I wanted to spend a long time mulling over!

BELOW
I first used a digital camera on an assignment in South Africa, back in 2003. Since then, I have embraced the new technology and now pick up a film camera only rarely.

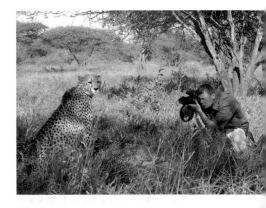

This section will cover the basics of digital photography, including some of the main advantages of the format as I see them. The points I record here are based on practical experience. If you are an experienced DSLR user you may want to skip this section, although you may also find some new information here.

HOW DOES IT ALL WORK?

Image capture

In digital photography, the basis of the photographic process remains unchanged: light enters the camera through a lens and an image is recorded on a photosensitive material. The amount of light that enters the camera is managed by a mechanical system that consists of an iris (the lens aperture) and a shutter, the exact amount required being, in part, dependent on the sensitivity of the material used. Once recorded, the effects of the change in state of the DPS (digital photosensor, or pixel sensor) are amplified to make a visible image.

The main technical contrast between the two formats is the medium used to record light. Traditionally, light was recorded by a strip of photosensitive film. Digital cameras, on the other hand, use a DPS—an array of individual light-sensitive cells (known as photodiodes) that sit within a grid. Each photodiode responds to the intensity of light that falls on it by generating a corresponding analog signal. This signal is converted into digital form—essentially, it is given a numeric value—so that a computer can read it easily. To add a color value, light passes through a filter array that sits in front of the DPS.

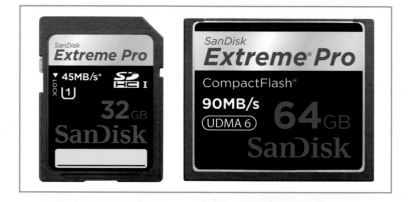

Image processing

When all photodiodes have a recorded value, they are aggregated to produce the image file. Additional processing may be applied by the camera at this point, such as color corrections and sharpening (see page 28), and the file may also be compressed using algorithms (see page 50) to save on memory/ storage space.

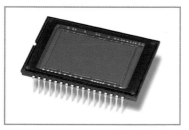

Image storage

Once this part of the image-making process is complete, the camera will write the file to a memory device, such as a CompactFlash or Secure Digital card (see page 40), where it is stored until it is manually deleted.

As the above description of the digital process illustrates, the digital camera is now far more than a "simple" light-tight box, like the traditional film-based camera. I will touch more on this point in the following chapter.

ABOVE TOP
Rather than storing captured images on film, a digital camera records data to a memory card, such as the Secure Digital High Capacity and CompactFlash cards shown here. Other than the obvious differences, the main advantages over film are greater security and larger capacity.

ABOVE
In a digital camera, the light-sensitive film is replaced by a photosensor.

THE TEN KEY STEPS OF DIGITAL WORKFLOW

Step 1 Light enters the camera via a lens, which projects an image onto the focal plane.

Step 2 The light passes through a red, green, and blue filter array.

Step 3 The light falls on the DPS and is converted into a pattern of pixels (picture elements) that contain information about brightness and color.

Step 4 These analog signals are converted by integrated circuitry into a numeric value.

Step 5 Microchips within the camera body analyze the data to form the completed image.

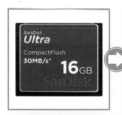

Step 6 This image is then passed to a memory device, where it is saved in a semipermanent state.

Step 7 Data is read from the memory device into a computer or computer device, where it can be viewed.

Step 8 Adjustments and enhancements can be made to the original image file using software tools, like those found in applications such as Adobe Photoshop or proprietary image-processing applications supplied with the camera.

Step 9 A final image is saved to a storage device, such as a hard-disk drive or DVD.

Step 10 The image can be printed for display or sent electronically to a third party.

WHY DIGITAL?

The advantages I illustrate here are based on my own experience and those of fellow professionals who have switched to shooting digital.

Flexibility

When you load a roll of film into a camera, certain parameters are fixed, such as ISO and color space (dictated by the type of film used). Digital technology overcomes these limitations by enabling many shooting parameters to be set for each individual frame. For example, if you have a break between taking photographs and light conditions change from very bright to excessively overcast, you can simply adjust the ISO-E (equivalency) to suit (more on page 60). You don't have to waste half a roll of film. Alternatively, one minute you're shooting landscapes, where a film such as Fuji Velvia arguably will give the best results, and the next you're photographing

the kids in the garden, where the same Velvia film would kill the image because oversaturation would ruin the skin tones. Again, digital has the answer: it allows you to switch between color-space settings depending on the subject being photographed (more on page 28).

Simplicity

Along the same lines, some of the parameters of film can be altered individually, but only with the aid of many accessories. For instance, using color-correction filters can alter the white balance of an individual film frame. But this is only possible if you own a complete set of CC filters (and there would be many of them in the set) and you have the right one with

you at the time. Adjustments like these are simplified with a digital camera because they can be dialed in as shooting parameters.

Instant playback

For many photographers, the most useful feature of the digital format is the ability to see instantly the picture they've taken. The LCD screens on DSLRs are fallible, but they do provide valuable information about composition and exposure, which means that you can take the shot; analyze the result; make any necessary adjustments to camera position, focal length, or exposure settings; and reshoot. This instant-playback feature is the equivalent of using Polaroid film (still available even though the Polaroid company no longer manufacture it) but far more convenient.

Immediacy

The advantage of immediacy is less apparent to the non-professional user than it is to the professional. In the commercial world, it can make all the difference. Press photographers have been taking advantage of the immediacy of digital for some time now, taking pictures in the field that reach their editor's desk moments later. Wedding photographers now present the bride and groom with a framed picture at the reception rather than when they return from honeymoon, many days after the event. Even in my own field—wildlife— the immediacy of digital can give me an edge over the competition. I once won a contract to supply images from South Africa for an advertising feature because digital technology allowed me to present a set of final photographs within hours rather than days or weeks.

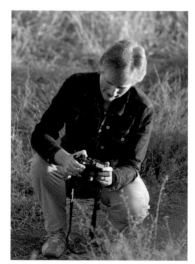

TOP, AND ABOVE
With digital you can simply change color space rather than rolls of film to capture skin tones and landscape shots. The effect of different color spaces is shown, top.

RIGHT
Instant playback of images in the field is one of the main selling points of digital photography.

Exposure control

Despite its limitations, the digital histogram (see page 88) provides useful information about the distribution of tones in an image that can aid a photographer to assess exposure. In addition, the highlights indicator information screen can be used to assess whether the brightness range of a subject exceeds the dynamic range (the ability of the sensor to record detail in highlights and shadows simultaneously) of the camera.

Running costs

Whether the true cost of digital photography is cheaper than film is open to debate. From a non-professional standpoint, with no film to buy or process digital certainly appears to be the cheaper option. Professionally, however, one must add in the cost of time to sort, edit, and process the digital image, along with the investment in expensive assets, such as professional-grade computers and monitors, high

capacity hard disk drives, and photo-quality printers. When these aspects are taken into account, the true cost of digital photography is higher than one might first believe. However, as with any technology, costs do fall and if you invest carefully in good quality equipment the long-term cost of digital photography is a highly acceptable proposition for most.

LEFT
Within moments of this image being taken, it had been electronically transmitted to a client in the UK. This ability to satisfy customer demand immediately has greatly increased the success of my business.

BELOW
The histogram has made attaining a technically correct exposure a far simpler task than ever before. Now there are no longer any excuses!

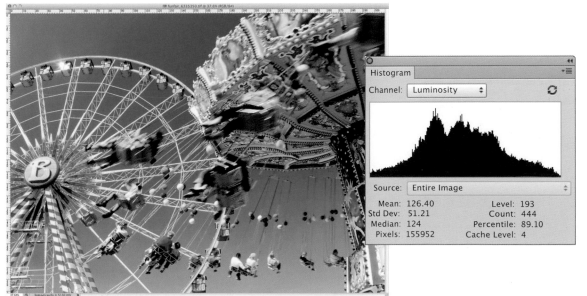

Traveling

So often while on photo-safaris, the number of times I have heard expletives emanating from the back of the jeep as another roll of film finishes midway through a spectacular action sequence just goes to prove that what can go wrong, will go wrong. With digital, this problem all but evaporates. The high-capacity memory cards now available can hold thousands of images, which means that the likelihood of missing that vital shot is negligible.

When traveling, you may have worried about your priceless images being ruined by airport X-rays. With digital, you can stop worrying. Most digital memory devices are impervious to X-ray (see page 44). Also, it's a lot easier to carry a couple of CF cards than numerous rolls of film.

Experimenting

One of the best ways to improve your photography is to experiment with different camera techniques. With film cameras there were two main drawbacks. First, it was expensive to shoot off several rolls of film just to see what effect you achieve. Second, it was, for all practical purposes, impossible.

For example, I could be experimenting with exposure settings while photographing migrating wildebeest in the Serengeti. The only chance I'd get to review the results was when I returned home to have the film

processed. Any changes I wanted to make would involve another trip to Africa, and I'd probably have to wait another year for the conditions to be similar. Even then, it is extremely unlikely that conditions would be exactly the same.

With digital technology, the camera is now an aid to experimentation and learning because of the immediacy of the playback. Commercially, this is a huge advantage, and for nonprofessional users it means that the speed at which your photography can develop and improve is greatly increased.

Are there any disadvantages? Yes, DSLRs do have some, many of which can be easily overcome.

Batteries

There is no doubt that digital cameras use more power than their film counterparts. Although power usage can be minimized—for example by playing back only selected images rather than every image you shoot—the power consumption of a digital camera is significant. Battery technology is constantly improving, and most DSLR models come supplied with an efficient power unit. Some older models, however, may use more traditional batteries that have a shorter operating life. This aspect should always be accounted for if you still

own and use older equipment. The other alternative, which is what I do even with my professional-spec camera, is to carry one or two spare batteries that are always fully charged.

Dust

Dust is definitely a problem. A lot of money is being spent in R&D departments around the world to find a long-term solution. Dust that enters the camera's main chamber is drawn to the DPS because of the sensor's electronic nature. Small particles of dust and dirt then stick to the low-pass filter that sits in front of the DPS and appear on images as blotches, which can at worst ruin a picture and at best create a lot of extra adjustment work. Several in-camera solutions exist, such as vibrating sensors that shake off the dust onto a removable sticky surface, and image-comparison technology.

ABOVE AND LEFT
Experimentation and learning from one's mistakes are major parts of developing photographic skills. Digital technology has helped this process enormously by allowing photographers to shoot, review, revise, and reshoot scenes within moments and while the opportunities remain.

Whichever DSLR you have, you will occasionally need to clean the sensor itself. This is a delicate operation and if you feel unsure about doing it yourself, then it is best to take the camera to an authorized service center.

If you limit the frequency of lens changes, this will help reduce the problem of dust, which is an advantage of using zoom lenses. Be careful when changing lenses (see page 30); this will also minimize the amount of dust that enters the camera. If all else fails and dust has affected some of your images then you'll need to use the CLONE tool in Adobe Photoshop to mask the resulting blotches (this technique is described on page 157).

Burst rate

The number of pictures that can be taken before the buffer fills and shutter lockout occurs (known as the burst rate) may or may not be a problem, depending on the camera you're using, the file type, and your style of photography. It only becomes a problem if you photograph fast-moving subjects, such as in wildlife or sports photography. File type will influence burst rate and you'll get more pictures when shooting in JPEG than in RAW or TIFF mode. Recent DSLRs have largely overcome this problem. Burst rate is an important factor when choosing a camera and it is discussed in more detail on page 66.

Price

As with most electronic products, the cost of entry into digital photography has reduced. When I first wrote this book, a DSLR camera was more than double its film counterpart. Today, entry-level DSLR cameras are available for as little as US$400-$450. Memory cards have also reduced significantly in price, with a professional spec card such as the Sandisk 2GB Ultra CF card costing around US$20. A 16GB card from the same manufacturer is around US$120. Non-professional spec cards are less still. Even computer equipment needed for image processing is less expensive today, in relative terms, than ever before.

Camera life

Just as you have to get your car serviced after so many miles, you should have the shutter mechanism of your camera serviced after a certain number of exposures. One side effect of digital photography is that users generally take more pictures, so the time between servicing reduces. As you might expect, professional cameras are more resilient.

BELOW
Your DSLR's "burst rate" is the rate at which it can take a rapid sequence of images, like this jumping fox. On many cameras, file type influences burst rate— you can shoot faster in JPEG mode than in RAW or TIFF—but recent models have largely overcome this problem, thanks to improved processor speeds and power.

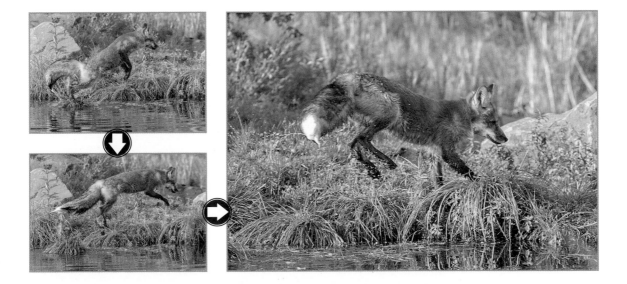

To this day a number of myths still attach themselves to the practice of digital photography and may serve to discourage you from taking it up. Here I will try to dispel those myths and present some basic facts about the digital format.

FILM GIVES A BETTER-QUALITY IMAGE

FICTION

A controversial topic: the subjective nature of this statement makes any debate about its merits a complex one. I will cover the detail behind my verdict later in the book, suffice to say that I have been selling digitally captured images for many years and have received no negative feedback on image quality—in fact, quite the opposite. Research shows that direct comparisons between the two formats reveals this statement to be fiction.

DIGITAL CAPTURE TAKES THE SKILL OUT OF PHOTOGRAPHY

FICTION

Quite the opposite is true. In fact, it could be argued that a greater understanding of the principles of photography is required because so much image processing can be set in-camera. This argument probably came about because of the ability to replay images and adjust them for errors. Yet you still need to understand how to compensate for inaccuracies. This is how we learn new skills anyway, by trying things out, analyzing the results, and making the necessary changes. All digital photography does is speed up the process.

DIGITAL PHOTOGRAPHY IS EASY. IF YOU GET IT WRONG, YOU CAN SIMPLY ALTER IT IN PHOTOSHOP

FICTION

While it is true that you can make certain adjustments to an image with image-processing software, in much the same way you could use selective processing in a darkroom with film, the simple truth remains that if the information doesn't exist in the first instance, no amount of "manipulation" will change it. An out-of-focus picture is out of focus, no matter what you do to it in Photoshop. This statement also assumes that we all know how to operate Photoshop or its equivalents with the skill of a technophile.

DIGITAL CAMERAS SUFFER FROM SHUTTER LAG

FICTION

As far as the DSLR is concerned, this statement is also a myth. It is true that some early compact digital cameras suffered from shutter lag, up to a second in some cases. However, the shutter lag present in DSLRs is comparable to film cameras and has no discernible effect in practice.

Image courtesy of Apple

DIGITAL STORAGE IS UNRELIABLE. CDS AND DVDS WILL BE OBSOLETE IN A FEW YEARS' TIME

FICTION

Although CDs and DVDs are likely to be replaced entirely by Blu-Ray discs in the future, backwards compatibility means that you will be able to continue using CDs and DVDs in Blu-Ray drives.

FILM IS DEAD

FICTION

I'm a digital convert and not even I agree with this one. There is still a place for film in many areas of photography and film will be with us for some years to come. For example, in landscape photography, I still marvel at the sight of a pin-sharp 5 x 4in transparency on the lightbox.

DIGITAL CAMERAS ARE MORE COMPLEX THAN FILM CAMERAS

FACT

In general this is true. However, it shouldn't put you off. I started working professionally with a digital camera just a couple of weeks after acquiring my first model, a Nikon D100. I had no digital experience but found it easy to switch from shooting film. Much of the technology built into a digital camera need only be used once you have mastered the basic camera techniques relevant to all photographic formats. It will give you greater flexibility in the future.

DIGITAL CAPTURE HAS CHALLENGED THE LEGITIMACY OF PHOTOGRAPHS

FACT

There is little doubt that we now question the legitimacy of any great picture, assuming that anything that appears too good to be true must have been created in Photoshop rather than in-camera. This is an attitude I find disconcerting and infuriating but I fear is one we'll have to live with.

DIGITAL PRINTS NEVER LOOK AS GOOD AS THE IMAGE ON THE SCREEN

FICTION

This is typically the case when the components within the workflow—the camera, workstation, software, and printer—have not been set up to work in unison. See my tips on color management on page 28 for more advice.

DIGITAL CAMERAS ARE OBSOLETE AS SOON AS YOU LEAVE THE SHOWROOM

FICTION

In the early days of digital photography product life cycles were short, as technology quickly moved on. However, the pace of change has now slowed and there is no reason that a DSLR camera bought four years ago should be considered obsolete.

Developments in digital camera technology

Since this book was first written, many new digital cameras have come onto the market, from entry-level DSLRs to top of the range cameras aimed at the professional user. During this period, the most significant changes in camera technology have been in the areas of resolution and usability.

For example, the resolution of even the most basic DSLR camera is now 10 megapixels, with some consumer models boasting image sensors with more than 16 megapixels. The viewing screen on my D100 was 1.8in with 118,000 pixels. The rough equivalent camera today (the D700) has a 3in VGA screen with 920,000 LCD pixels. Other developments have been made in camera automation, with additional auto-exposure mode options, automated ISO functions, and improved auto-focus systems. However despite the many changes, most of these developments have been evolutionary, improving but not radically altering, the basic camera.

The number of new camera models has certainly slowed a little in recent years as the technology consoildates itself. Nikon's professional-specification DSLR, the D3, is still going strong with two model choices, and the D700, first released in the summer of 2008, is also still a popular choice. However, interesting innovations at the consumer end of the market continue to appear. Nikon's new D5100 model features a flip-out wide angle screen which has not been a regular feature of DSLRs in the past. The variable angle of view makes using this camera on a tripod very easy, and it is great for self-portraits too.

ISO ranges of 1600 or more that are capable of producing images with remarkably low noise levels are also continually on the increase. Materials technology also contributes to development, with high-end models featuring Kevlar and carbon fiber componets that enable increased performance in areas such as burst rate. DSLRs are even being used to shoot high-quality, HDMI video for an increasing variety of media.

In my opinion, these are the areas where we will see further developments in the coming years. The pixel race is largely over— future improvements will see more sophisticated analog to digital (A/D) conversion and improved dynamic range, possibly toward the point where an affordable high-dynamic range (32-bit) camera becomes available with the ability to record detail across even the broadest scene dynamic range.

LEFT
The Nikon D700 assures professional image quality with low noise, high-ISO performance.

The Digital Single Lens Reflex (DSLR) Camera

More than a light-tight box

At first glance, a digital SLR and a film SLR look much the same; the most significant external difference is the addition of an LCD screen on the back of the digital camera. However, if you were able to look inside, you would see a significantly different piece of kit. In fact, you would be looking at a full-fledged computer that comes complete with a mini-monitor, a central processor, RAM (random access memory), and a removable hard-disk drive.

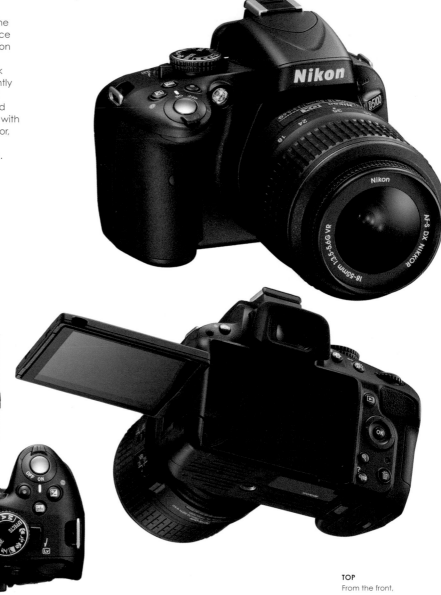

LEFT
From the top, this DSLR offers one or two clues that it is a digital model, such as the info button and the effects mode.

ABOVE
The Nikon D5100 features a flip out LCD screen, an innovative approach for the consumer level DSLR market.

TOP
From the front, the average DSLR has little to distinguish it from a traditional film-type SLR, but there is a lot more going on within the camera body.

Although modern film cameras have developed a long way beyond the "nothing more than a light-tight box" epithet with which they have often been labeled, the fact remains that their sole purpose is to record light on a photosensitive material. The remainder of the photographic process is completed outside of a film camera, in a processing lab or darkroom.

Not so the DSLR. Effectively, all three stages of the process can, to a certain degree, be completed in-camera—image capture, image processing, and image storage.

RIGHT
Digital cameras are far more than simple light-tight boxes. These devices are sophisticated computers in their own right, with processors, RAM memory, semi-permanent storage, and even a monitor— in fact, just like your desktop or laptop computer at home or at work. All this technology once came at a considerable cost, but now DSLRs are a mainstream option, prices are drastically lower than they were only a few years ago.

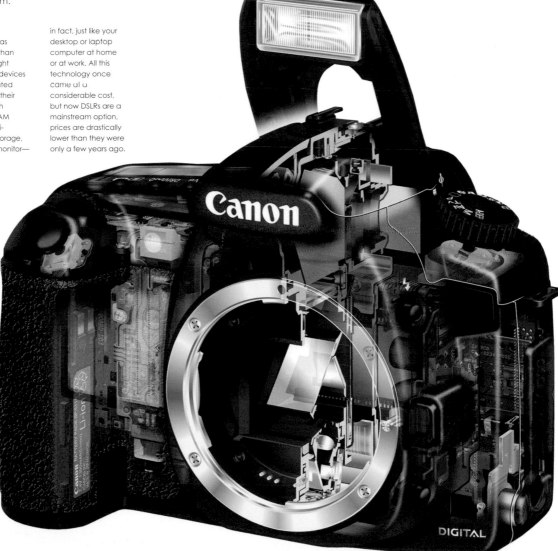

Camera specifications

DSLRs come in three main groups: those aimed at the beginner or inexperienced user, such as the Nikon D3100, the Canon EOS-1100D, the Pentax K-r, and the Sony A330; those with a more sophisticated amateur user in mind, such as the Nikon D700, the Canon Eos 7D, the Pentax K-7, and the Sony A580Y; and those aimed at the professional user, such as the Nikon D3x or Canon EOS-1Ds Mark 3.

The aspects of these cameras that typically differentiate them from each other are, at the professional end, a more powerful and sophisticated A/D converter and high resolution sensor, a faster and more accurate auto-focus system, fast frame rates (up to 11fps), and robust build quality. The mid-range cameras tend to have similar sensor resolution, but without the same level of A/D converter. At the entry-level end of the market, the cameras are designed primarily for ease of use. They are more lightweight, without the rugged build quality of the top models, have slower and less sophisticated AF systems, and frame rates of around 3fps.

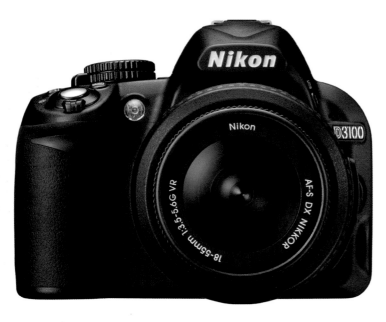

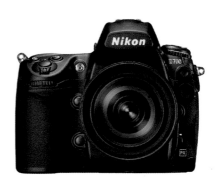

ABOVE
The handsome form of the Nikon D3100 is a current example (at the time of writing) of an entry-level DSLR.

ABOVE RIGHT
In the middle are the "pro-sumer" DSLR models, such as the Nikon D700 (see page 16). These cameras combine the simplicity of use of the entry-level machine with some of the technology of the higher-spec pro cameras.

RIGHT
At the opposite end of the spectrum are the high-end professional specification DSLRs, such as the Nikon D3X, built to withstand the rigors of a professional working environment.

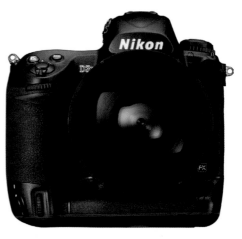

Choosing a DSLR

It's a given in the digital world that technology is constantly changing and generally getting better all the time. Yet for the vast majority of users, all of the current crop of 10+ megapixel DSLRs on the market will provide all the functionality you're ever likely to need (and quite a few options you won't) and produce exceptional quality images up to at least letter-paper size (around 12 x 8in), and larger.

The deciding factor should always be how the camera is to be used. For example, if you're likely to want to photograph sporting events and are considering trying to sell your pictures, then you'll need a camera with fast and reliable AF and a high-speed frame rate, such as the Canon EOS 1D (and its derivatives) or the Nikon D3x or D700. On the other hand, if your main interest is photographing events for the family album, then an entry-level, consumer-specification model, such as the Nikon D3000 or D3100, will suffice for many years to come.

ABOVE AND RIGHT
Your choice of DSLR should be driven primarily by your style of photography. The needs of sports photography (above), for example, differ greatly from those of landscape work (right). Before you settle on any given camera, make sure that it offers the necessary level of functionality to meet your specific needs, rather than simply following market trends or going for what appear to be bargains.

HOW DOES A DIGITAL PIXEL-SENSOR (DPS) WORK?

The DPS is an array of millions of light-sensitive cells, or photodiodes (PDs); each one responds to the amount of light that falls on it when the shutter is activated. A corresponding signal is then created that, in turn, is digitized—given a number value—so that a computer can read it.

Simply put, it's a little like painting by numbers. Imagine taking a piece of white paper divided into a grid of several million squares. Now, using the value of the electrical charge that corresponds to each sensor on the array, color each square to match. For example, if the charge was zero, no light would reach the sensor, and you could color the square black. If the value was high, a lot of light would reach the sensor, and you could leave the square white. Values in between could be assigned different shades of gray, and once you'd completed the whole sheet, if you were to reduce each square to a tiny size, you would

have an accurate black-and-white picture of the original scene. In a nutshell, this is how digital photography works.

Color is assessed by way of a red, green, or blue filter (corresponding to the primary colors of light) that covers each cell and allows it to respond to a single light frequency.

The filters are arranged in a group of four: one pair of red and blue, and one pair of green. This additional green filter is used because human eyesight is more sensitive to green light. (See below for a description of different color filter types.)

Once a number value has been assigned to each cell, the cells are processed by the camera, which gives each pixel a color value calculated (or, in digi-speak, interpolated) from the data gathered from adjacent cells. This is a vital part of the process and is one reason why image quality is not solely determined by the size of the sensor or the number of pixels it produces.

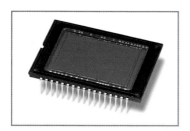

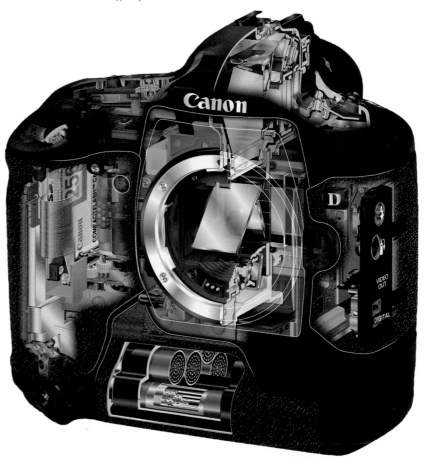

ABOVE
The DPS is the heart of a digital camera. It is this device that records light and forms the photographic image.

RIGHT
The DPS records light in terms of the grayscale. Color is achieved by the use of color filter arrays that sit in front of the DPS.

ABOVE
The digital process is a little like painting by numbers. Each of the millions of photodiodes on the DPS records the brightness level of light that hits it and assigns a brightness value. If you enlarge the image enough, you can see these individual "squares" of light (top). As you reduce the size of each resulting pixel they become less discernible, resulting in what we actually see, a high-quality photographic image (right).

TYPES OF SENSOR DESIGN

There are two main types of photo-sensor used in digital photography: CCD (charge-coupled device) and CMOS (complementary metal oxide semiconductor). In principle, every DPS works in much the same way but different types use the information that they capture in different ways.

CCD

In a CCD-based sensor, the data from each individual cell must be read off in turn, one by one. Therefore, the whole area must be scanned to retrieve the data and the reading must be completed before a further exposure can be made. This can slow down the process and limit how quickly pictures can be taken one after the other. There are other limitations. CCDs tend to be power-hungry and so sap the batteries quicker than a CMOS device. They also suffer more from color artifacts (faults), in which the sensor will "cover up" slight discrepancies in patterns during processing; this can lead to a loss of image quality. On the positive side, CCDs are far simpler and cheaper to produce than CMOS devices and are more popular among manufacturers, and market forces are pushing down prices further still. Additionally, they don't suffer from the same extraneous electronic noise that early CMOS sensors did, giving a far "cleaner" image.

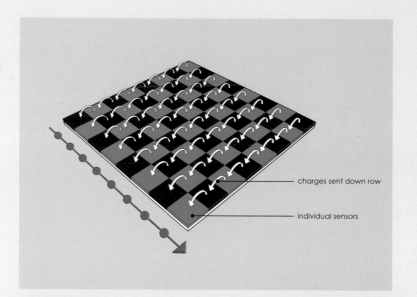

charges sent down row

individual sensors

ABOVE
How the DPS manages the data it records influences many factors, including image quality and frame advance rates. This diagram shows how some CCD devices pass information from the DPS to the processor.

RIGHT
The DPS sits behind the reflex mirror, in a position similar to where the film frame would be in a film camera.

Full-frame transfer CCD

In 2003, a digital camera with full-frame transfer capability was launched. This system differs from the interline process described above and is managed by the actual pixels, rather than a separate channel. The main advantage of this type of system is image quality. Because no transfer channel exists to take up space within the pixel, the light-receiving PD can be made physically larger, allowing more light (or electrical charge) to be received by that pixel. In turn, the larger electrical charge requires less amplification to produce the final image in the first instance, and in this way it increases the signal-to-noise ratio (decreasing the level of noise) and enables an overall increase in the dynamic range of the sensor.

CMOS

From the manufacturers' perspective, CMOS devices are far more flexible than CCDs and can be put to many uses above and beyond simple image capture (such as exposure metering, for example). This added flexibility does make them more expensive. From the user's point of view, the main advantage of a CMOS device is greater integrity in recording detail and therefore improved image quality. Early CMOS devices, however, suffered from high levels of digital noise that reduced image quality, which was a main factor in the decision of manufacturers to use CCDs. This problem has been overcome and newer CMOS devices, such as those used in Canon's high-end SLR cameras, have solved this issue. Also, because CMOS sensors run off a single low voltage, their propensity to use up your stock of batteries quickly is reduced.

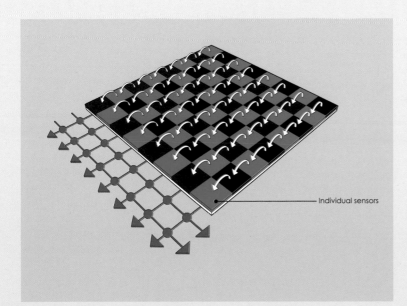

Individual sensors

LEFT
CMOS sensors operate differently to CCD devices. The ongoing debate as to which sensor type is best for digital photography has been answered largely by the manufacturers who now mostly install CMOS sensors in their high-end cameras. In reality, however, each sensor type has its advantages and disadvantages depending on the type of camera.

COLOR FILTERS

Types of color filter

Currently, there are two main types of color filter used in digital photography—the Bayer pattern mosaic filter, and the Foveon image sensor.

The mosaic filter is by far the most common type of filter in use at present. In it, a single filter (red, green, or blue) is centered over an individual sensor, with two green filters for each pair of blue and red in an array. Each filter then passes light frequencies that correspond to their own color and also some others. For example, a blue filter passes mostly blue light frequencies but also some green.

The Foveon image sensor works slightly differently, in that it features three layers of photodetectors embedded in silicon. This takes advantage of the fact that red, green, and blue light penetrate silicon at different depths, which allows all three colors to be measured at each pixel. The advantage of this type of system is that full color is captured by the sensor. With mosaic-type filters, each photosensor captures just one predominant color (red, green, or blue), and relies on interpolation to assess, or "guess," the correct level of the other two. Depending on the sophistication of the interpolation software, this can lead to color artifacts and a loss of image detail. Theoretically, the Foveon image sensor delivers better sharpness and color detail, and from the feedback I've received from professionals who use this technology, it doesn't disappoint.

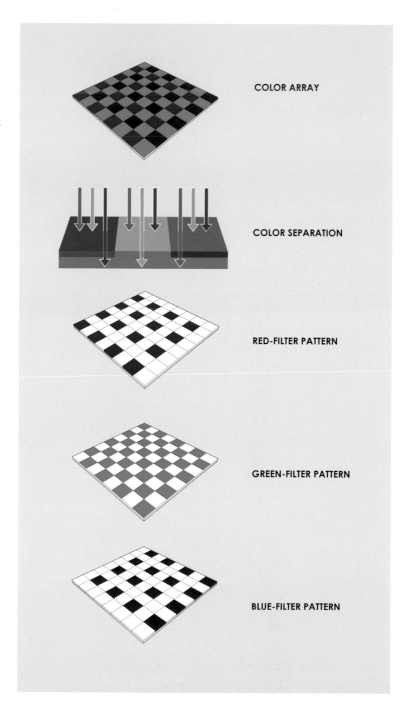

COLOR ARRAY

COLOR SEPARATION

RED-FILTER PATTERN

GREEN-FILTER PATTERN

BLUE-FILTER PATTERN

Making a choice

Most buyers of digital cameras make their choice of system based on a number of parameters that, more often than not, take precedence over sensor and color-filter type. The choice may be made because you have already bought into a particular system, either directly or when upgrading from your existing film outfit, or other factors may influence your decision, such as system backup or price. Once you've decided on a particular model of camera, you have no choice over the sensor or color-filter type.

THE FOUR THIRDS (4/3) STANDARD

Many digital cameras, particularly SLRs, have been designed around existing 35mm camera formats and use lenses that were originally manufactured for film-based photography. The problem with this is that film and DPSs record light in slightly different ways. Film is sensitive to light falling on it from oblique angles, and subsequently, lenses are not necessarily designed so that light hits the film head on. Image sensors used in digital cameras, on the other hand, are designed with inherent differences, which make them most effective when light hits the light-gathering photodiodes head on. Light that strikes from any other angle is not effective in reaching the photodiode and image quality is reduced; this is seen on the final image as vignetting and poor color reproduction, particularly around the edge of the picture space.

The four thirds format was developed with the aim of optimizing the performance of both image sensors and lenses. In this format, the diameter of the lens mount is approximately twice as large as that of the image circle. Thanks to this design, most of the light strikes the image from nearly head on, ensuring clear colors and sharp details even at the periphery of the image. So why not just design lenses like this for existing DPSs? To achieve the same standards, the lenses would be far too large and unwieldy.

RIGHT
Digital photography needs light to hit the DPS at as close to 90 degrees as possible for maximum quality. The four-thirds format was designed to achieve this.

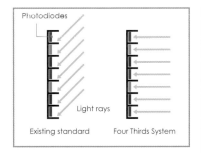

RIGHT
The four-thirds format utilizes a system whereby the diameter of the lens mount is twice as large as that of the image circle.

FAR RIGHT
The Foveon color filter array uses a different design to that of more traditional Bayer-type filter arrays (previous page).

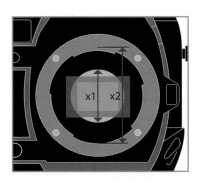

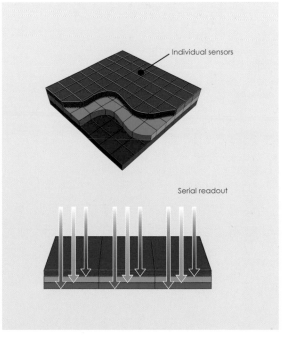

Types of lens

There are many different lens types available today from various manufacturers, ranging in both physical size and focal length. They provide photographers with a multitude of options when considering compositional values. They range from wide-angle lenses that accentuate space to telephoto lenses for cropping in close, macro optics for extreme close-ups, and tilt and shift lenses for precision applications. In addition, a growing number of digital-specific lenses has entered the marketplace recently. With all this choice, how do you choose?

Understanding lenses

The purpose of the lens is to focus the rays of light that reflect off your subject onto the DPS. To achieve this, lenses use a minimum of one lens element (usually in very inexpensive cameras) or a group of many elements, which optimize the transmission of the image.

The focal length of the lens is the distance between its optical center, which may necessarily vary from the physical center, and the DPS plane, or focal point, which is indicated in millimeters (mm) and is related to the magnifying power of the lens.

In 35mm film photography, a 50mm lens is referred to as a "standard" lens because it is closest to the human field of vision. (In fact, 43mm—the diagonal of the 35mm frame—is the true equivalent to human vision but 50mm was decided upon by the manufacturers to avoid complicating the issue.) Due to the smaller size of many DPSs, the 50mm "standard" focal length will vary between DSLR models (see page 36). For example, with a Nikon DSLR the equivalent "standard" focal length is closer to 33mm.

ABOVE LEFT
The primary role of a lens is to focus the light rays entering the camera body on the image plane.

ABOVE RIGHT
As well as own-brand lenses from the camera manufacturers, the quality of the optics built by the "independents" has made them a suitable choice for many photographers.

LEFT
Because of the difference in the way a sensor gathers light compared with film, lens manufacturers now design lenses exclusively for use on digital cameras.

ABOVE
Choice of focal
length influences
perspective and
spatial relationships,
as we can see from
these shots taken with
four different lenses,
from wide angle (top
left) clockwise
through to telephoto.

Focal length, magnification, and perspective

Lenses come in varying focal lengths, from super-wide-angle to super-telephoto. The focal length will determine image magnification. For example, a 50mm lens has an image magnification factor of 1. A 100mm lens will double the size of the image (magnification factor 2x), a 200mm lens will quadruple the size of the image (magnification factor 4x), and so on. A 24mm wide-angle lens, on the other hand, will roughly halve the size of the subject in the frame (magnification factor 0.5x) and

a 12mm lens will reproduce an image one quarter of the size of a 50mm lens (magnification factor .25x). When photographing small animals or subjects that are some distance away, a telephoto lens will help magnify the subject so that it takes up more of the image space and appears larger than a mere speck on the horizon.

More than just altering subject size, however, your choice of focal length will also influence perspective and spatial relationships. By moving closer

to your subject with a wide-angle lens, you can maintain subject size in relation to the image space but completely alter the relationship the subject has with its surroundings. A wide-angle lens increases the space between pictorial elements, giving a perception of wide-open spaces. A telephoto lens, on the other hand, compresses the distance between objects and isolates subjects from their surroundings, which will usually be out of focus.

LEFT AND ABOVE
This series of images shows the effects of changing focal lengths. The camera position has remained unchanged but focal length has varied from 24mm, 50mm, 100mm, 200mm, 400mm, and 800mm. In each case, subject magnification has doubled.

Lens speed

The speed of a lens is determined by its maximum aperture and refers to its ability to gather light. The larger the maximum aperture, the more light it can gather and the faster the lens is said to be. The advantage of a fast lens is greater choice in selecting exposure settings. Most professional lenses will have fast apertures (f/4 or f/2.8 for super-telephoto lenses, and f/2.8, f/2, or even f/1.8 for shorter focal length lenses), while those aimed at the enthusiast market tend toward

f/5.6 as their fastest aperture. The difference is not just in price, but also in size and weight. If portability is more important than speed, then the slower lens should be your choice. But if getting the image at all costs is more important, then you may prefer to pay the additional few thousand dollars and suffer the extra weight of the faster optic.

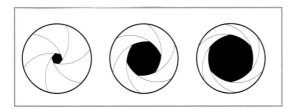

LEFT
The diaphragm controls the quantity of light that is passed through to the DPS. Large apertures let in more light than small apertures, and lens aperture also affects depth of field, (see page 110).

BELOW
The maximum aperture of a lens determines its speed. Fast lenses, such as this f/2.8 telephoto lens are generally larger and heavier than slower lenses.

ABOVE
Many consumer-grade lenses have smaller maximum apertures, which has the advantage of making them more compact and lighter.

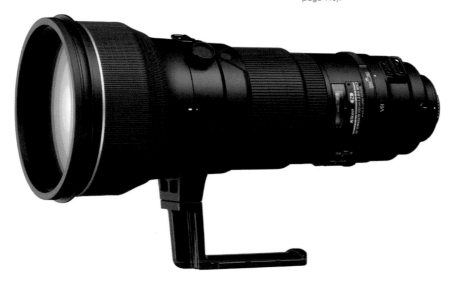

The diaphragm

You can reduce the amount of light passed by the lens by adjusting the lens aperture using a mechanical diaphragm. The diaphragm opens and closes the iris to make it larger or smaller and is controlled by a rotating ring on the lens barrel, or, more commonly with modern cameras, via a command dial on the camera. Lens aperture is represented by a series of markings, typically f/1.8, f/2, f/2.8, f/4, f/5.6, f/8, f/11, f/16, f/22, and f/32. These rounded values correspond to the focal length and aperture diameter, and the area of the aperture doubles with each increase in stop (i.e. an aperture of f/8 lets in twice as much light as an aperture of f/11).

BELOW
Shots like this are a familiar challenge: achieving a good exposure in difficult lighting conditions against a setting sun, by stopping down the aperture to let in less light. With DSLRs, you can preview the results to get the best exposure.

THE FOCAL LENGTH MAGNIFICATION FACTOR

Because seasoned photographers are used to 35mm cameras, we tend to consider focal length and perspective in these terms. For example, a 50mm lens on a 35mm camera is referred to as "normal" or "standard" because its angle of view is close to that of the human eye, which means what the camera "sees" of the scene and what we see are nearly the same. With most (though not all; see note opposite) digital cameras, the focal length of the lens has an apparent magnification factor because the DPS has a smaller area than that of 35mm film. The operative word in the above sentence is "apparent," and in reality, focal length is completely unaffected. What does change, however, is the angle of view. This is seen as a real advantage for some photographers, particularly those in the field of sports and wildlife, because a 400mm lens, for example, has an angle of view similar to a lens of 600mm. Landscape and architectural photographers, on the other hand, are less happy.

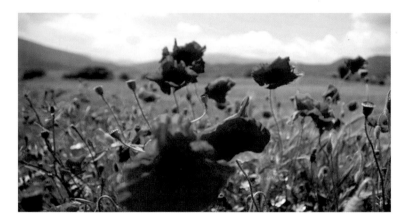

It is critical to avoid confusing focal length with angle of view. Irrespective of the dimensions of the recording device (small-frame DPS, full-frame DPS, or even film), the physical size of the subject remains the same with any single given focal length. For example, if you photographed a grizzly bear with a 35mm film camera and a 400mm lens, and the image of the bear was reproduced on the film at 18mm in height, it would be reproduced at exactly the same size if photographed using a small-frame digital camera with a 400mm lens, although the reduced field of view would remove some of the visible space around the bear and would make it appear closer to the camera.

This distinction is important when it comes to enlarging the image. Both film and digital images require exactly the same amount of enlargement. For example, to reproduce a print of the bird in which it was 180mm in height, it would be necessary to enlarge the image ten times.

ABOVE AND TOP (OPPOSITE)
Taken on a 35mm frame the image above shows more background area around the poppies than the image taken with a similarly positioned Nikon digital camera (opposite). This is the effect of the "focal length magnification" factor.

BELOW
Compared to a 35mm film frame, most DPSs are of reduced size and create the "focal length magnification" factor.

DPS Lens

35mm frame

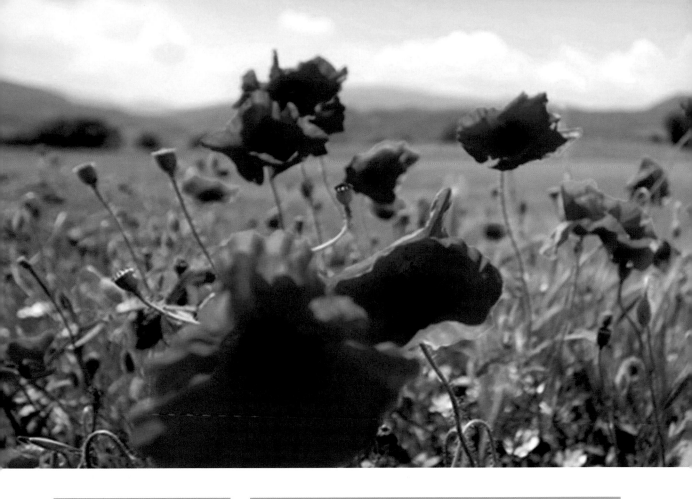

FULL-FRAME DPSS

Some digital cameras, notably some models from Canon and Nikon, have what is called a full-frame sensor, which means that it has the same surface area as 35mm film and, as such, angle of view is unaffected.

RIGHT
This table shows how different camera makes and models affect perceived focal length.

THE EFFECT OF THE MAGNIFICATION FACTOR (MF) IN DIGITAL PHOTOGRAPHY

Focal length with 35mm film camera	Equivalent focal length field of view with 1.5x MF (e.g., all current Nikon DSLRs)	Equivalent focal length field of view with 1.6x MF (e.g., Canon 10D)	Equivalent focal length field of view with 2x MF (e.g., Olympus E1)
17mm	26mm	27mm	34mm
20mm	30mm	32mm	40mm
24mm	36mm	38mm	48mm
28mm	42mm	45mm	56mm
35mm	52mm	56mm	70mm
50mm	75mm	80mm	100mm
60mm	90mm	96mm	120mm
80mm	120mm	128mm	160mm
100mm	150mm	160mm	200mm
135mm	200mm	216mm	270mm
200mm	300mm	320mm	400mm
280mm	420mm	448mm	560mm
300mm	450mm	480mm	600mm
400mm	600mm	640mm	800mm
500mm	750mm	800mm	1,000mm
600mm	900mm	960mm	1,200mm
800mm	1,200mm	1,280mm	1,600mm

Some figures have been rounded up or down to their nearest equivalent.

Lens manufacturers, notably Nikon, Olympus, Tamron, and Canon make equipment specifically for digital cameras. So what's the difference between a digital lens and a nondigital lens? The answer to this question lies in telecentric lens design. Because of its physical depth, for each photodiode on the DPS to receive the maximum possible charge, light has to fall on it from as close to 90 degrees as possible.

Otherwise, if the angle is too great, then much of the information for that area of the scene is lost, which causes vignetting, discoloration, and noise (most often seen at the edges of the frame). A telecentric lens design maximizes the quantity of light that hits the sensor at very close to a right angle, which optimizes image quality.

ABOVE LEFT
Because light has to pass through to a DPS as close to 90 degrees to the perpendicular as possible, many companies are now producing lenses designed specifically for digital cameras.

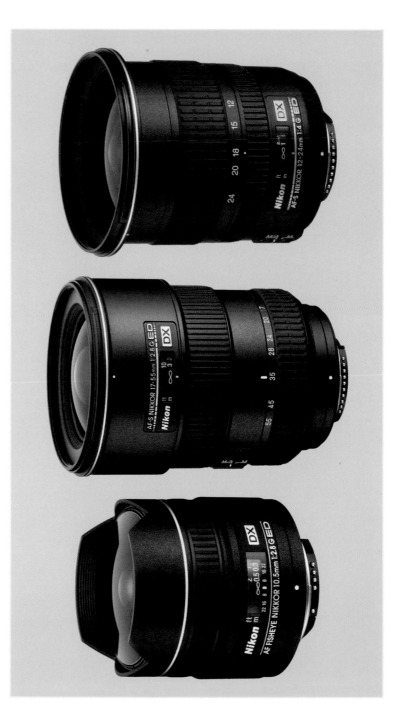

TOP TEN TIPS FOR CHOOSING LENSES

1. You get what you pay for
Always buy the most expensive lenses you can afford. It's better to have a less expensive camera body and a quality lens than vice versa. Remember that it is the lens that passes the information used in photography (i.e., light) through to the DPS, which then records it. If the information isn't there to start with, you'll never recreate it on a computer.

2. Zoom lenses
Zoom lenses provide the greatest flexibility in composition and allow you to alter the focal length exactly as needed. When choosing a zoom lens, try to avoid extreme zooms (e.g., those that have a very wide range, such as 70–500mm or 28–300mm) because the quality of these optics is compromised by their versatility. Digital specific lenses for small-format DSLR cameras also tend to be smaller and lighter than their 35mm format equivalents, as the image circle can be made smaller.

3. Prime lenses
Prime lenses (i.e. lenses of a fixed focal length), while less versatile than zoom lenses, are generally of better optical quality. In the main, this is due to the reduction in the amount of glass that light has to pass through. For some extremes, such as very wide-angle lenses and super-telephoto lenses, image quality will be noticeably better when using prime lenses.

4. Low-dispersion glass
Lenses that use low-dispersion glass help minimize chromatic aberration, a type of image and color dispersion that occurs when light rays of varying length pass through optical glass. In so doing, they improve sharpness and color correction in your final image.

5. Autofocus
If speed of focusing is important to you, then test AF performance before you buy any AF lens, because some systems are much slower than others.

6. Internal focusing (IF)
IF lenses are more compact and lightweight in construction than lenses where the barrel extends outward when focusing.

7. Aspherical lens elements (ALEs)
Lenses with ALEs produce better image quality by eliminating the problem of coma and other types of aberration, which are particularly prevalent in wide-angle lenses used in conjunction with wide apertures.

8. Maximum lens aperture
The maximum aperture of the lens will, to some extent, dictate the level of control you have over exposure settings. For example, in low light conditions with a "slow" lens (e.g., a lens with a maximum aperture of f/5.6 or less) you may not be able to attain the shutter speed necessary to freeze motion or capture a sharp image. On the other hand, with long telephoto lenses, a wide maximum aperture dictates a very large and heavy lens, which can be difficult to carry and support. When selecting a lens, try to determine beforehand the conditions in which you are most likely to be taking photographs, and balance maximum aperture with portability.

9. Maximum aperture and zoom lenses
With some zoom lenses, the maximum aperture can vary depending on the focal length set. This system is used to reduce the size and weight of the lens but again can limit your options when it comes to setting exposure. If possible, always opt for a zoom lens with a fixed maximum aperture.

10. Lens hoods
Lens flare is caused by stray light from a bright source, such as the sun, falling directly onto the front element of the lens and then bouncing around the inside of the lens barrel. You will notice it as polygonal shapes on your pictures, which do nothing for composition and artistic merit. You can minimize the effects of flare by attaching a lens hood to the front of the lens, which helps to soak up any stray light. Always use the lens manufacturer's recommended model.

Memory cards

Once a DSLR has captured and processed an image, it transfers that image from its internal buffer onto a memory device inserted in the camera body—unless it is downloaded straight to a computer, which is possible with some DSLRs.

The purpose of the memory device is to provide semipermanent storage of images until they can be downloaded to a computer's hard-disk drive or another form of long-term storage media, such as a DVD or Blu-Ray disc.

The most popular forms of storage media used in DSLR cameras today are the CompactFlash (CF) and Secure Digital (SD) cards. These devices are small (but not too fiddly), robust, and reliable. They range in capacity from around 2GB up to 128GB and come in either "consumer" or "professional" grade. The key difference tends to be the speed at which the card can read and write data—the professional spec cards having very fast upload and download speeds that maximise the camera's burst rate. Smaller DSLR cameras tend to use the smaller SD-type memory cards, while IBM Microdrives have disappeared from the scene.

BELOW

The choice of both consumer and professional grade CompactFlash and SD cards is considerable, and capacities are now much higher. Even Micro SD cards which are small enough to fit in smart phones can now hold up to 32GB of information.

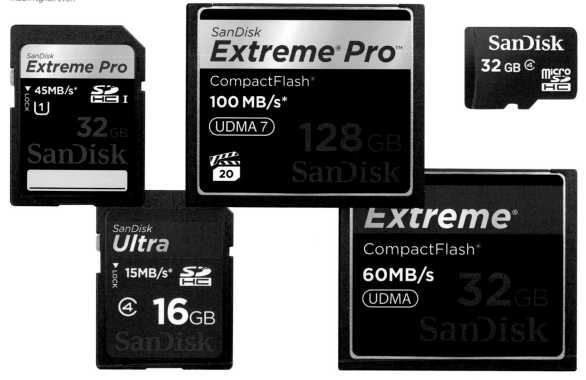

DIGITAL FILM

Memory cards are often referred to as digital film, which is a little misleading since they are nonsensitive to light, have no light-recording capacity, and play no part in image capture. The only property they share with film is the ability to store a captured image. In reality, the DPS is the closest equivalent to film.

BELOW
Although there are exceptions to the rule, the memory card is the link between the recording mechanism (the camera) and the viewing device (the computer or printer) in the digital workflow.

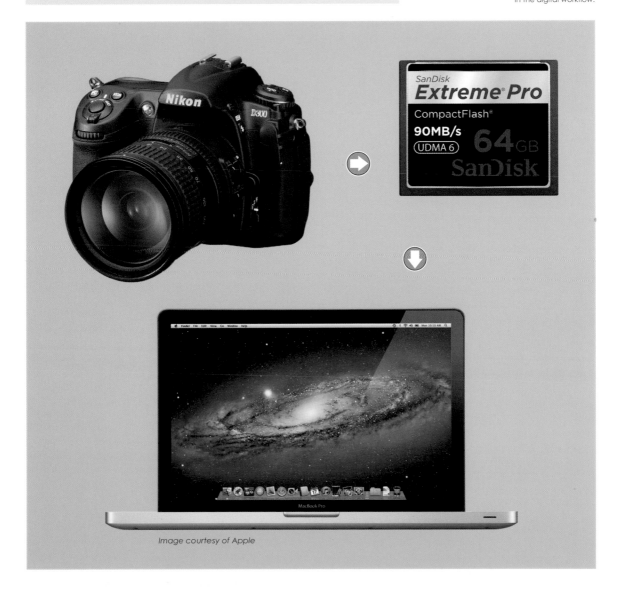

Image courtesy of Apple

CompactFlash (CF) cards

CompactFlash cards use solid-state technology (i.e., they have no moving parts), which makes them less fragile and less susceptible to excessive heat generation and increased power usage. They come in various different sizes, from around 2GB to 128GB and with different write (data-transfer) speeds. The larger the capacity of the card, the greater the number of images it can hold; and the faster the write speed (quoted as, for example, 20x, 40x, 80x), the quicker the data is transferred out of the camera's internal buffer, which can speed up burst rate. However, to use some of the larger-capacity and faster cards, your camera needs to support Lexar Media's Write Acceleration (WA) and FAT32 technologies. (You'll need to refer to the manufacturer's specifications to check whether this applies to your camera.)

Secure Digital (SD) cards

There are various types of SD card available. The SDSC (standard capacity) card has an official maximum capacity of only 2GB but the SDHC (high capacity) card is available in capacities up to 32GB, so a popular choice for manufacturers.

TYPE I AND TYPE II CF CARDS

There are two physical sizes of CF cards, referred to as Type I and Type II. Type II cards are thicker, and while some DSLR cameras accept both card types, earlier models tended to accept only the thinner Type I device. The main difference between the two types, other than the physical size, is capacity, Type II cards having a much higher range of capacities than Type I cards.

WHAT'S THE IDEAL CARD SIZE?

There is no definitive answer, but I prefer to shoot with nothing greater than a 4GB card and frequently use a 2GB card. This is because I find it easier to manage a card containing fewer images than one with several thousand. I frequently download my images from the card to a long-term storage medium so that if the card fails or is lost, damaged, or stolen, I don't lose several hundreds or thousands of images.

INTERPRETING WRITE SPEEDS

The following table provides the actual speed of data transfer for given CF card write speeds:

Card speed	Data transfer speed (Megabytes per second)
8x	1.2
12x	1.8
20x	3.0
25x	3.8
30x	4.5
40x	6.0
60x	9.0
66x	10.0
80x	12.0

LEFT AND FAR LEFT
You can store more low-resolution ("res") images than high-res shots. The image, far left, is a RAW file. Top left is a medium-res JPEG, and bottom a low-res JPEG. Note the increased pixelation and blurriness.

CONSUMER VERSUS PROFESSIONAL CARDS

Most reputable manufacturers of CF cards offer two versions of card, one for the consumer market and one for professionals. The main difference is in write speed, the latter offering much faster data-transfer speeds. For some forms of professional use this can be essential, but most users will find the standard card types perfectly adequate for their needs.

LOOKING AFTER YOUR MEMORY CARDS

Better safe than sorry

Memory cards are inserted into the camera body so that images captured by the DPS can be saved onto them. The first time you use the card you may need to format it, which is done using the menu option on the camera. Once in use, you can remove the card at any stage, either to change it for a different card or to transfer the written files to a computer (using a card reader, for example) or other storage device, such as a portable hard disk drive. You can also erase any images you don't like as you go along, to make room for more pictures. The only time you shouldn't remove the card from a device is when it is being accessed. Always refer to the indicator lights, which show you when it is safe to remove the card.

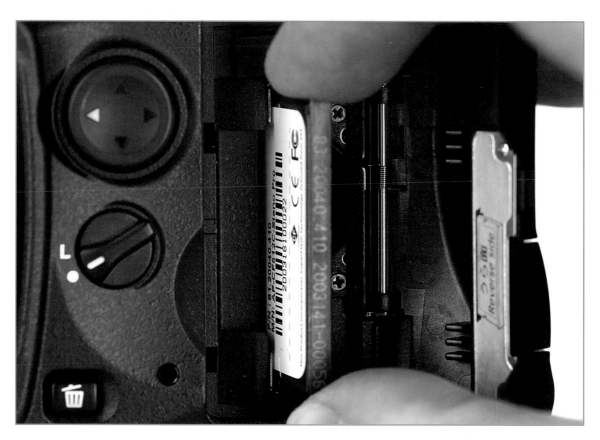

FORMATTING STORAGE CARDS

Storage cards should be formatted before first use and when exchanged between different camera models. For instructions on formatting, refer to your camera's user manual.

MEMORY CARDS AND AIRPORTS

In my experience, memory cards are unaffected by either the low-powered handheld X-ray machines, or the more powerful devices used to scan luggage at airports, despite contrary claims.

ABOVE
CompactFlash cards are more robust than MicroDrives. Nevertheless, take care with all memory cards—they might be easier to carry than a bag of film, but they are also far more easily lost.

ABOVE
Adobe Bridge, supplied with Adobe Photoshop, allows you to quickly browse the contents of any CF card, or indeed any image archive you have stored on your computer. Keywords can also be added to help you locate the images using the search facility.

RIGHT
If you own an Apple you'll have access to iPhoto, an image cataloging application supplied as part of the OS X operating system. It offers numerous easy-to-access features that allow you to keep track of the contents of your image library.

2

55 45 35

VR

AF-S NIKKOR 18-55mm 1

Digital Basics and Image Capture

Setting up the camera

There's far more to photography with a DSLR than simply switching on the camera, setting exposure and focus, and taking the shot. More decisions have to be made before you compose the image, which will slow down your picture taking. In itself, this is no bad thing. Talk to photographers who use sheet-film (4 x 5in, 8 x 10in) cameras and they will tell you that one of the many benefits of large-format photography is that it makes you think more about what you're doing, which usually leads to better pictures. Using a DSLR, you'll need to consider file types, picture quality, and white-balance settings. These tips will help you to make the right decisions.

SHOOTING MENU

White balance	A
ISO	200
Image sharpening	+/-0
Tone compensation	0
Color mode	II
Hue adjustment	0
File compression	OFF
Image quality	RAW

LEFT
There are far more considerations that need to be taken into account before pressing the shutter of a DSLR rather than a traditional film camera, as this list of menu options shows.

BIT SIZE

Photography is all about capturing varying levels of brightness across the picture space. At 12-bits, each photodiode can handle 4,096 levels of brightness, while at 14 bits the same photodiode can record 16,384 brightness levels. Conversely, at 8-bits the figure drops to just 256 brightness levels. Therefore, bit size has a significant influence over image quality. The greater the number of levels, the more likely the camera is to record the scene accurately.

JPEG CONVERSION

It can be argued that because a RAW 12- or 14-bit file is linear and an 8-bit JPEG file is a nonlinear transform derived from the original 12- or 14-bit data then, in the shadow areas at least, the two are alike because the full nonlinear coding preserves the full resolution. I would rather have the added, across-the-board benefits of RAW.

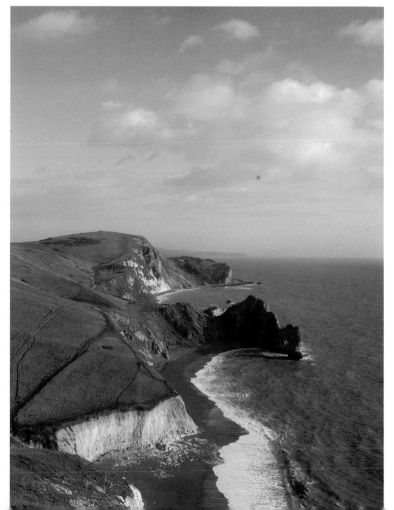

Selecting the file type

When you take a picture with your digital camera, each photodiode records an analog signal that corresponds to the amount of light hitting it. The camera's built-in electronics then digitize the signals. Depending on the camera, the digital data contains either 12- or 14- bits.

In RAW mode, the camera retains all 12- or 14-bits of data, which are then available later to work with on a computer. If, however, you save the file as a JPEG, the camera converts the image to an 8-bit file, which reduces the number of brightness levels you have to work with. This is

an important consideration if you plan on managing any post-camera processing. Also, remember that every time a file is saved in JPEG format, it is compressed.

LEFT AND FAR LEFT Which file type you select will influence the quality of the final output. To the naked eye, differences in image quality are often undiscernable, as these two pictures show. The image left was saved in-camera as a JPEG file, the image opposite as a RAW file. When considering photographs for commercial use, absolute image quality is paramount.

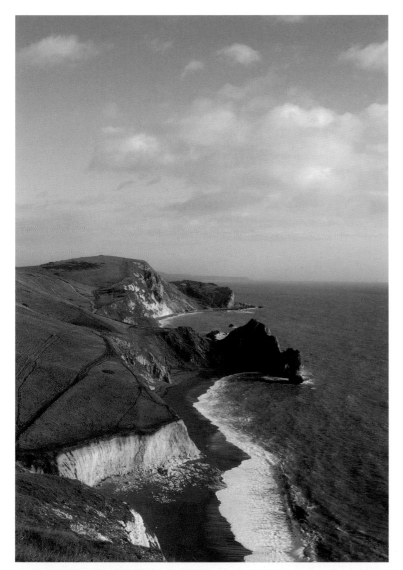

A FINAL WORD ON FILE TYPES

Some will argue that post-camera processing is for techno-geeks and that amateurs and serious photographers get the image right in-camera, and therefore have no need for RAW data. Such views are, in my opinion, naive. Just ask Ansel Adams.

For specialized photographic applications, such as press photography, perfect image-reproduction quality is unnecessary and can be compromised for speed of capture and delivery. However, in other fields, speed is less of an issue and the flexibility of the RAW mode is relevant; it's easy to reduce quality from a high-resolution original but impossible to work in the opposite direction.

Also, speed of capture is relative. The time lapse between taking the picture and the finished item is indeed shorter with a JPEG due to the reduced requirement for post-camera processing. But image quality is only maintained if the in-camera quality parameters are set for each individual shot, which slows down the picture taking at the point of capture.

IMAGE CAPTURE

The in-camera processes for saving RAW and JPEG files differ. When you save an image in RAW mode, the camera records the actual data captured by the DPS. It applies no in-camera processing; instead it appends a header file that contains all the shooting parameters (white balance, saturation, contrast, etc.) that were set by you at the time of capture. This data is sent to the memory card as a compressed or uncompressed file. Any compression applied is "lossless" (see page 53).

The process for saving an image as a JPEG file is much longer (longer being a relative term here) because the camera processes the data as it goes along, adjusting color, brightness, sharpness, contrast, and saturation levels. It then converts the full resolution file into 8-bit mode and the file is compressed using "lossy" compression algorithms (see page 53). Both file types have their advantages and disadvantages. The option you should choose depends on your style of photography.

RAW FILE IN-CAMERA PROCESS

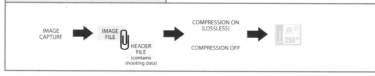

JPEG FILE IN-CAMERA PROCESS

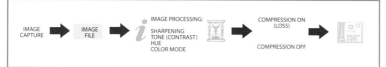

TIFF FILES

Some cameras support the TIFF file extension. Like JPEGs, TIFFs are processed in-camera and so have none of the advantages of RAW files. They are also large, and so lack JPEGs' size advantage. The one plus they do share with a RAW image is that any compression applied is lossless. Few applications require you to shoot TIFF in-camera.

ABOVE TOP
The in-camera process for RAW and JPEG files differ. When an image is shot in RAW mode, the camera completes no processing but instead attaches a data file that indicates camera settings at the time of capture. This file is later accessed by computer software and some settings can be directly altered in-computer.

ABOVE
When the JPEG file type is selected, image processing takes place in-camera, although additional processing can be completed later on a workstation.

ADVANTAGES OF SHOOTING IN RAW MODE

1. Having a RAW file is the equivalent of having an endless supply of exposed but unprocessed film. It holds only the data captured at the scene without any other variables applied, which means you can use different processing techniques as frequently as you like, taking advantage of new and improved software applications.

2. Shooting parameters such as white balance, sharpening, and saturation can be adjusted after the picture has been taken as though they were set at the time of shooting, which minimizes the likelihood of image degradation. It's a little like having the ability to retrace your steps and reshoot the scene as often as you like. These parameters can be adjusted on a JPEG file, but because a gamma curve has been applied to the JPEG file, alterations cannot be made with the same accuracy.

3. Color conversion is done in-computer using more sophisticated algorithms than the camera's built-in processors can handle, which improves image quality.

4. RAW files take advantage of the computer's 16-bit mode, giving a total of 65,536 brightness levels to work with, as opposed to just 256 with a JPEG file. This makes post-camera processing a far more expansive application, giving you greater image-processing options than are available with JPEG files.

5. You can create a JPEG file from a RAW file, but you can't do the reverse. Similarly, you can compress a large file to make it smaller, but once the JPEG algorithms have discarded unused data you can never be sure of recreating the file exactly as it was.

ADVANTAGES OF SHOOTING IN JPEG MODE

1. JPEGs are much smaller in terms of file size, hence more can fit on a memory card. For example, an 8GB card will store around 2,040 high-resolution or 8,000 low-resolution JPEGs compared to just 900 RAW images taken on my Nikon D3S. Similarly, the burst rate (see page 13) is affected. I can shoot 40 consecutive high-resolution JPEGs and only 25 RAW images on the same camera—a loss of well over one-third in productivity.

2. While you can argue the limitations of JPEG processing algorithms, the reality is that, there is very little visible difference between a high-resolution JPEG (referred to as a FINE JPEG by Nikon and Canon) and a RAW file.

3. Because JPEG files are smaller in size, they can be transmitted more easily over the Internet. This is relevant for professional press photographers and photo-journalists. If you are shooting exclusively for the Internet or want to e-mail images, then shooting in JPEG mode makes sense.

4. Because JPEG files are processed in-camera, you can produce high-quality finished images straight away—if you know how to get the most out of your equipment. This makes post-camera processing less important. If you prefer to spend time taking pictures in the field, then using the JPEG format will help reduce the time you need to spend in front of a computer afterwards.

5. JPEGs can be opened in any graphics software application, which negates the need to use software supplied by the camera maker. This can save time in your digital workflow because it removes one stage from the process.

RAW CONVERSION

Most cameras use a proprietary extension when images are shot in RAW mode. For example, Nikon uses the extension .NEF and Canon uses .CRW. This extension determines the code used when a RAW file is constructed. However, despite the proprietary nature of these files, most RAW image files can be opened in non-proprietary software packages such as Adobe's Camera Raw plug-in and Lightroom applications, and Apple's Aperture application, when the relevant plug-in is added.

There is also an open format RAW extension used by some manufacturers called .DNG. Any RAW converter software can open a .DNG file, without the need for a plug-in. Pentax is an example of a manufacturer that provides the .DNG option in its camera file mode options. You can also save RAW files as .DNG files using Adobe Camera RAW, which provides the advantage of making them future proof. If Adobe drop support for older camera models in the future you will still be able to open your .DNG image files.

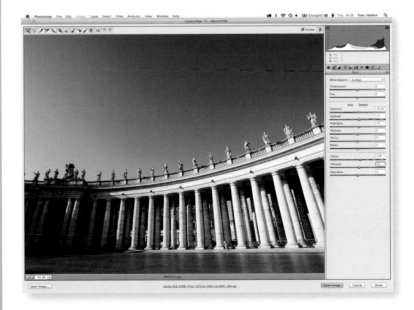

RESOLUTION

Resolution is a complex subject; it's important to understand it insofar as it affects image quality.

As outlined earlier (page 24), a DPS is an array of photodiodes laid out in a regular grid pattern. These photodiodes create pixels (short for "picture elements"). Generally speaking, the greater the number of pixels, the higher the image resolution will be.

In this sense, resolution is the measure of the total number of pixels on the sensor, or the sum of the number of pixels across multiplied by the number of pixels in height. For example, an image sensor that measures 3,072 pixels x 2,048 pixels has a resolution of 6,291,456 pixels—more commonly referred to as 6.2 megapixels.

It makes sense that a DPS with 6.2 megapixels can capture greater detail than a smaller sensor. In basic terms, this is true. However, there is an important caveat to add because an element of image quality is also dependent on how many of those pixels are used for image capture (effective pixels), as well as a number of varying parameters, such as their size, shape, and configuration.

For example, photodiodes are sensitive only to a certain range of brightness levels (known as the sensor's dynamic range) and this range varies between sensors from different manufacturers. The higher the dynamic range, the greater the amount of information that can be captured. Therefore, it's feasible that a camera with a lower number of total pixels than another has a higher image resolution.

A better question to ask is how many pixels are actually needed, and the answer to that depends on your use of images. For example, many people scoffed when Nikon launched its professional 4.1 megapixel D2H. However, this camera was aimed squarely at the press market for which 4.1 megapixels is more than adequate; the majority of their images appear reproduced on low-grade newspaper. However, for the professional stock photographer, something akin to Canon's 5D MkII is more appropriate.

For printing purposes, the table opposite outlines some simple parameters for making decisions about image resolution.

ABOVE
Image resolution becomes more apparent the larger the size of the reproduction.

ABOVE, FROM LEFT
This series of images shows the effects of different levels of JPEG compression. From left, the first is a RAW file with no compression applied;

Image two is a FINE, or HIGH resolution, JPEG; image three a NORMAL or MEDIUM resolution JPEG; and image 4 a BASIC, or LOW resolution, JPEG.

WHAT'S THE DIFFERENCE BETWEEN TOTAL PIXELS AND EFFECTIVE PIXELS?

Camera manufacturers usually provide two pixel counts with their marketing blurb: total pixels, and effective pixels. When determining image resolution, only effective pixels are relevant and provide a more accurate indication of image resolution. This is because some of the pixels on a DPS are used for tasks other than recording light.

PRINT SIZE	MIN. PIXEL DIMENSIONS
3" x 2"	600 x 400
6" x 4"	800 x 600
7" x 5"	1,400 x 1,000
10" x 8"	2,000 x 1,600

FILE COMPRESSION

When a file is compressed using loss compression technology (i.e., JPEGs), algorithms are used to reduce the physical size (in bytes) of the image file. Once the file is compressed, some original data is discarded permanently. When it is opened, algorithms are again used to reconstruct the image with the missing data replaced with "guessed at" information. This can sometimes result in a loss of image quality, and the appearance of artifacts (faults).

Most cameras offer different levels of JPEG compression. These levels are often called FINE, NORMAL, and BASIC. The compression ratios used in each are roughly as follows:

FINE = 1:16, NORMAL = 1:8, BASIC = 1:4

It is worth noting that each time you re-save a JPEG, it applies additional loss compression, thereby reducing image quality with each re-save.

Lossless compression (RAW, TIFF), on the other hand, compresses the data to reduce the file size but retains all the original data. When the file is retrieved, the computer reconstructs the image with exactly the same data that it started with, and image quality is maintained at the original level.

There is a rationale behind using loss compression. The advantage is that file sizes are much smaller than those created with lossless compression, which aids transmission over the Internet or via a computer network.

In some lower end models of camera the application of file compression in-camera can significantly slow down the processing time. In other models, such as the Nikon D3X and D700, compression actually speeds up the processing of images between the DPS and the memory card.

Although we can't see it, light at different times of the day (e.g. sunrise and noon), under different weather conditions (e.g. cloudy versus sunny), and from different sources (e.g. natural daylight and continuous-source studio lighting) varies in color.

Humans perceive all light to be neutral white, irrespective of its source, time of day, or conditions. This is because we have a built-in white balance (WB) control in our brains. In technical terms, the purpose of the WB control in your camera is to operate in the same way as the WB control in your brain, i.e. to record all light as neutral white.

Light temperature can be measured using a scale known as degrees Kelvin (K). Midday summer sunlight on a clear day, for example, is around 6,000K. On the same summer day, however, the temperature of light around sunset is only about 2,000K—far warmer than the bluer midday light. The opposite table provides an outine of color temperatures under different lighting conditions.

SHOOTING MENU	
White balance	A
ISO	200
Image sharpening	+/-0
Tone compensation	0
Color mode	II
Hue adjustment	0
File compression	OFF
Image quality	RAW

COLOR TEMPERATURE OF LIGHT

Light source	Color temperature
Candle	1,000K
Early sunrise	2,000K
Low-effect tungsten bulbs	2,500K
Household lightbulb	3,000K
Studio photo floodlights	4,000K
Typical daylight; electronic camera flash	5,500K
Midday sunlight	6,000K
Bright sunshine on a clear day	7,000K
Slightly overcast sky	8,000K
Hazy sky	9,000K
Open shade on a clear day	10,000K
Heavily overcast sky	11,000K

OPPOSITE
WB affects how the DPS reacts to color casts caused by fluctuations in light temperature, (measured in degrees Kelvin [K]). The three images (opposite, top, and below) show how adjusting WB alters the final output. The image opposite was shot with the WB set to DAYLIGHT, or SUNNY (around 5,200K).

BELOW
Set to the SHADE setting (around 8,000K), the images shows a strong orange cast.

ABOVE
The effect of setting WB to CLOUDY (around 8,000K).

Applying white balance for artistic effect

When WB is set to Auto, the camera will always attempt to nullify any color casts created by the prevailing lighting conditions. Often, however, this has a negative affect on composition. For example, imagine photographing a beautiful golden sunrise only to find that the camera has filtered out the orange/yellow light. In nature photography, when the photographer wants to exploit colorcasts for artistic effect, WB can be considered as a set of digital color filters, which can be applied in the same way you might use an 81 series warming filter or an 80 series blue filter.

Under the WB menu option are several preset WB values: SUNLIGHT, CLOUDY, SHADE, INCANDESCENT (Tungsten), FLOURESCENT and FLASH.

When set to SUNLIGHT (the Flash setting is very similar) the result is an unfiltered image. Effectively, this is the same as photographing using daylight-balanced film without any filtration. This will result in any colorcast present, caused by a variation in actual color temperature compared to the color temperature set via the WB control, showing in the final image.

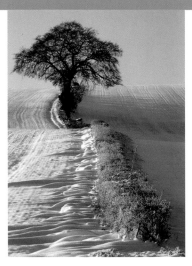

ABOVE Snow and ice are supposed to appear blue and setting the WB to a warm temperature, such as CLOUDY, would have spoiled the picture. Instead, I set WB to DAYLIGHT.

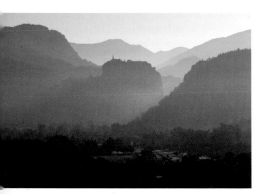

AUTO WHITE BALANCE IN THE STUDIO

Auto WB may produce unrealistic results when used in conjunction with studio strobe lighting. Instead, use PRESET WB or set WB manually.

ABOVE LEFT For this early morning image I set WB to CLOUDY to enhance the warm effect of the light.

BELOW LEFT For portraits, a more natural color cast is required and I set the WB to DAYLIGHT for this outdoor shot.

RIGHT Because of the street lighting, a DAYLIGHT setting renders the picture too orange (top), compared to the better, more natural picture below (WB set to INCANDESCENT).

HOW LIGHT TEMPERATURE AFFECTS AESTHETICS

The color of light will affect the emotional impact of your photographs. For example, landscape and wildlife images often look far more appealing when the color temperature of the light is warm. Snow and ice, on the other hand, look more aesthetic when they are seen under cooler conditions that are more representative of their physical state. Portraits and candid shots of people generally look best when the light is neutral, or white.

To enhance warm tones, i.e. replicate the use of warming filters, the CLOUDY or SHADE settings can be set. The CLOUDY setting is similar to an 81B warming filter, and the SHADE setting is closer to the stronger, more pronounced 81C or 81D warming filters.

To enhance cool blue tones, the FLOURESCENT and INCANDESCENT settings can be applied. In this case, FLOURESCENT is similar to an 80C or 80D blue filter, while INCANDESCENT will mimic an 80A or 80B blue filter.

By thinking of WB in terms of filtering orange or blue light, the WB control can be used to create artistic effects and enhance the color temperature of light. For example, in landscape photography, warm images often stand out because they have a positive psychological effect (humans are warm blooded creatures and like to feel warmth). Enhancing the warm tones of sunrise and sunset by setting WB to either CLOUDY (mild effect) or SHADE (strong effect) will improve your images, as if an optical warming filter had been used.

ABOVE AND LEFT
These images show the comparison between the DAYLIGHT WB setting (above) and the CLOUDY setting (left). Note the warmer appearance of the images where WB has been set to CLOUDY.

ABOVE AND RIGHT
Compare the two images here. The first picture (above) was taken with WB set to DAYLIGHT, while for the second image (right) I set WB to SHADE for a more pronounced effect.

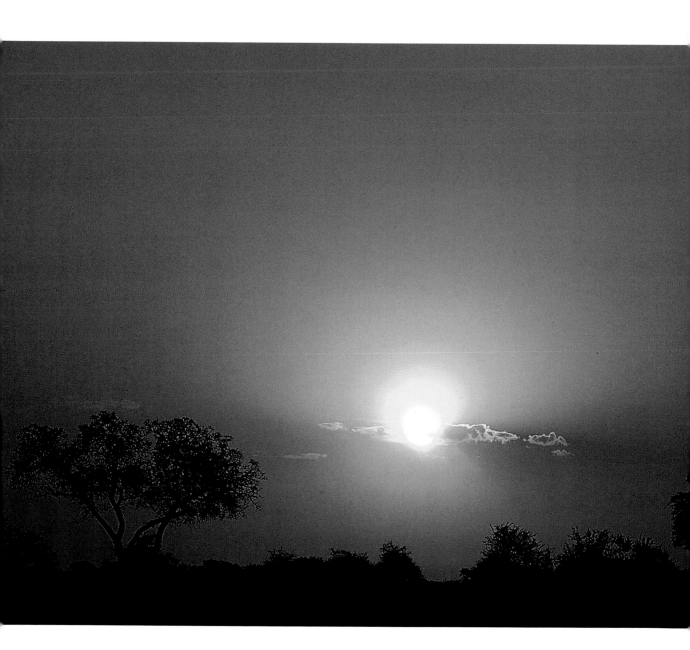

Using the WB PRESET setting

Using this setting on your DSLR involves taking a measurement of light temperature from a reference point, usually a neutral gray or white object (an 18 percent gray card is ideal if you can place it in the same light as the subject). The result should be a "close enough" K value to produce a photograph with neutral lighting. (Refer to your camera manual for an exact operational guide.)

LEFT
Setting WB is not an exact science. There are occasions when what would appear to be the right setting will produce very poor results. For scenes such as this sunset, you will need to select a WB setting that matches your vision. (Here, WB was set to SHADE.)

WHITE BALANCE AND OPTICAL FILTERS

Some DSLRs have an external WB sensor as well as a TTL sensor (e.g., the Nikon D2Xs). It is easy to obscure the external sensor, which will result in inaccurate settings. For example, I usually wear a baseball cap when taking photographs, but the peak of the cap casts a strong shadow over the external WB sensor in my D2X, which is mounted in the prism.

WB SENSORS

Be wary when using optical color correction filters with your DSLR. With some exceptions, DSLR cameras measure WB through the lens (TTL) and any color correction filter will affect the accuracy of the WB reading. On the AUTO WB setting, this can result in pictures having an unnatural color cast, and when applied with programmed settings it can negate or accentuate their effect.

SHOOTING MENU	
White balance	A
ISO	200
Image sharpening	+/-0
Tone compensation	0
Color mode	II
Hue adjustment	0
File compression	OFF
Image quality	RAW

In digital photography ISO relates to the extent to which the light signal received by the sensor is amplified. The higher the ISO rating the greater the level of amplification applied and the less signal (light) is needed to create a workable exposure. For example, in very bright conditions where light is plentiful, ISO may be set to a low value (e.g. ISO 100). However, in dim lighting a faster ISO might be needed in order to set an adequate exposure value. It is important to

COPING WITH DIGITAL NOISE

At higher ISO-E ratings, particularly above ISO-E 400, you will notice that digital noise affects image quality. To minimize noise in-camera, try turning on the NOISE REDUCTION function, found in the menu options. Noise can also be minimized in post-camera processing using specialist software applications, such as Dfine by nik software.

SHADOW AREAS

Noise is always more apparent in the shadow areas of an image. Although shadows can be lightened during post-camera processing, lightening them where noise is apparent may increase the visibility of noise and create color artifacts, or faults.

understand two main facets of ISO:
1. The higher the ISO rating the less signal (light) is needed to create an exposure
2. The higher the ISO rating the greater the possibility of noise adversely affecting image quality

Noise

Amplification noise is a result of two things. Firstly, the reduced level of light signal needed to produce the exposure results in a lower signal to noise ratio, which increases visible noise. Secondly, as the signal and noise are amplified simultaneously, the noise that is present becomes even more obvious.

The solution to noise, then, is to always shoot at low value ISO ratings (e.g. ISO 100 or 200) and to avoid long-time exposures if you can.

MAXIMUM USEABLE ISO VALUES

The maximum useable ISO value of a camera will depend on many things and will vary between models. In commercial use, the general rule is to set as low an ISO value as you can get away with. For most DSLRs an ISO rating of 400 or lower will produce good quality results; beyond ISO 400 noise will need to be managed post-capture. Some of the higher specification cameras will perform well at ISO 800, while the current champion, the Nikon D3S, is capable of producing commercially useable images up to an incredible ISO 12800. However, high spec doesn't always equal high useable ISO values. For example, the Nikon D2X is a particularly noisy camera, that I wouldn't use above ISO 200.

ABOVE LEFT
At fast ISO-E ratings, digital noise becomes apparent, particularly in shadow areas.

ABOVE
To eliminate the effects of digital noise, set an ISO-E rating of below 400.

Like most modern SLRs, your DSLR will have multiple shooting modes, usually including single frame and multiframe, as well as a self-timer. They also have a maximum burst rate—this is the number of frames that can be exposed consecutively before the camera needs time out to process the captured data.

Single-frame or continuous shooting

Your subject will determine whether you opt to shoot in single frame (SF) or continuous frame (CF) mode. Typically, when photographing static subjects, such as landscapes, architecture, or still life, there is little reason to use up battery power and fill up your camera's buffer (see page 66) shooting in CF mode. When your subject is moving, however, CF mode will allow you to expose several images within a short space of time without having to worry about constantly pressing the shutter release button. This mode is used frequently when photographing action—for example, in sports and wildlife photography. The disadvantage of CF mode is that the buffer can fill up quickly, disabling the camera momentarily (see page 66).

High-speed continuous frame mode

Early DSLR cameras had a relatively slow CF mode of around 3 frames per second (fps). For many nonprofessional users, and for photographers who rarely shoot fast-action subjects, this was, and still is, more than adequate. Recently, DSLRs have caught up with film cameras in frame rate, and mid-range to high-end professional digital cameras have a frame rate of between 5 and 11fps.

While these figures sound impressive, their usefulness in general, everyday photographic applications is minimal. Outside of photographing very high-speed action, few subjects move so fast as to warrant eight pictures in a second, and I have found that for all but the most specialist of applications, a lower frame rate of 3 or 4fps actually produces better results.

ABOVE
For fast-action shots a high frame rate will help ensure you don't miss the photo opportunity.

RIGHT
With static subjects such as landscapes, fast frame rates are unnecessary and single-shot frame advance is adequate for the task.

ABOVE AND RIGHT
Being able to anticipate progressive movement will help overcome the limitations of slow-frame advance cameras. I took this series of images with the camera set to 2fps and paid close attention to the subject.

Overcoming the limitations of reduced-speed shooting

However, what happens when you are photographing a motor rally or a cheetah in full-speed pursuit of its prey, for example, and your DSLR only provides for 3fps shooting? There's no need to spend several thousand dollars on upgrading to a higher-specification professional camera simply to increase frame rate. There are skills you can learn to overcome the limitations of slower frame rates.

The trick is to use the viewfinder effectively and know your subject. Many photographers consider the viewfinder as nothing more than a frame. In reality, it is far more than that, and high-speed frame advance is often the tool of lazy photographers. Get to know your subject inside out so that you can anticipate motion and actions. This will enable you to have the camera in the right place at the right time, which is far simpler than

always trying to catch up with the action. Use the viewfinder to watch what is happening, and determine the most appropriate moment to fire the shutter. There is a difference between seeing and visualizing, and the contrast between the two is the difference between keeping your fingers crossed and being certain of getting the shot.

BURST RATE

 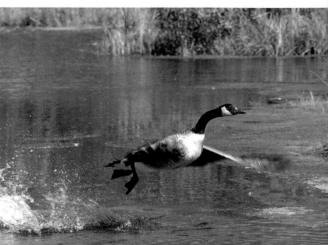

Burst rate and the DSLR buffer

A 35mm film camera has a typical burst rate of either 24 or 36 frames—i.e., the length of the roll of film. The burst rate of a DSLR camera is determined primarily by the size of the memory buffer.

The memory buffer acts in a similar way as the RAM (random access memory) in your computer. This is where all the current data is held before being stored on the permanent memory device (a hard disk in a computer, and a CompactFlash or similar memory card in a DSLR). The larger the buffer, the more data can be stored there, temporarily, and the greater the number of images that can be taken before it's full.

Of course, the number of images that can be held in the memory buffer will also be affected by the size of the image file. Large file sizes, such as those produced when shooting in RAW or TIFF mode, will take up more space, while JPEG files, which have reduced file sizes due to compression levels, take up less space and increase the burst rate accordingly.

Burst rate, or the lack of it, was one of the early disadvantages of digital cameras. I particularly noticed it when photographing wildlife with my Nikon D100. It had a burst rate of just four frames in RAW mode, after which it would lock out while it freed space in the memory buffer. Newer cameras have overcome the problem to such an extent that burst rate is now of little significance.

ABOVE
Shooting a rapid RAW sequence such as this used to be impossible, as cameras would lock up while the camera freed space in the memory buffer to process each shot.

RIGHT
Now, however, burst rate is no longer a problem for professional-specification cameras, and the lowering of prices and increase in quality means the consumer end of the market will soon benefit.

FRAME COUNTER

The frame counter in some DSLRs has two figures: the number of frames remaining on the permanent memory device and the number of frames remaining in the memory buffer, often indicated by the letter "r" next to the number—e.g., r12. Keep an eye on this latter indicator when shooting an action sequence as it will help you become more discerning when choosing when it is the appropriate moment to fire the shutter.

SIMULTANEOUS PROCESSING

Developments in DSLR technology allow the camera to process image data at the same time as recording new pictures, which has enabled continuous shooting, particularly when shooting in JPEG mode.

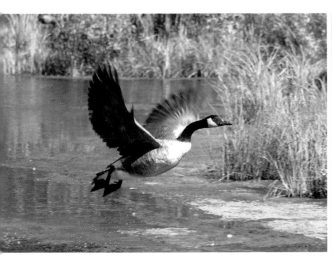

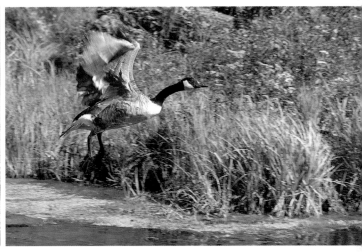

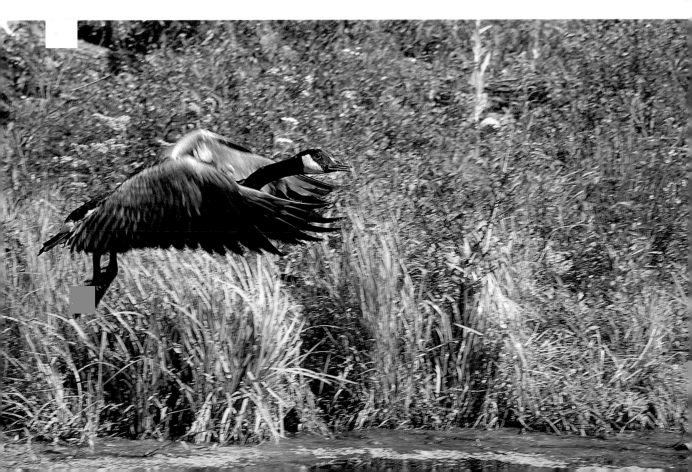

How light is measured

Photographically, light can be measured in one of two ways, by assessing either the brightness of the scene (reflected light) or the amount of light falling on the scene (incident light). Light meters are used to calculate an exposure value, which can be translated (either by the meter or by you) into a combination of lens aperture and shutter speed. The light reading will always be given in relation to the ISO equivalency you've set.

For the purpose of this book, I will ignore the incident light meter and concentrate on the DSLRs built-in TTL meter. TTL meters measure reflected light, and while the nuances of different models of camera may vary in the minutiae of the mathematics, all TTL meters work in much the same way.

How a light meter works

Every light meter is calibrated to give you an exposure value for a middle-tone subject, that is a subject that reflects 18 percent of the light falling on it. Examples of middle-toned subjects are leaf green, a clear blue sky at around 11a.m. on a summer's day, and poppy red.

With this line in the sand it is easy to begin to understand meter readings and, in particular, their faults. When you meter a subject, the light meter will give you a reading that will enable you to record it as a middle-toned subject. This is fine if the subject you're photographing is middle-toned. But what if it's not? To the meter it doesn't matter because it "sees" it as middle-toned. But to you it matters enormously because, in most situations, you will want to record it as it appears.

For example, say you are photographing a snowman in your garden. You set your camera to auto-TTL metering and take a picture. But the result is a snowman that looks gray and nothing like the brilliant white you remember. This is because the camera's meter "saw" it as gray—18 percent gray to be exact. Now take another picture, this time opening up

your exposure (adding more light) by around 2 stops. You will see that the snowman is reproduced looking exactly as you remembered it —brilliant white.

This happens because a camera will underexpose light subjects to make them darker and overexpose dark subjects to make them lighter—in the attempt to achieve a tone equal to 18 percent gray. In order to compensate for these exposure calculations, you must set the camera to do the opposite of what it has just done automatically. If you are photographing subjects lighter than middle-tone and the camera has underexposed the image, you must set it to overexpose by dialing in plus exposure compensation

or by manually opening up the exposure settings. If you are photographing a subject darker than middle-tone and the camera has overexposed the image, you must set it to underexpose by dialing in minus exposure compensation or closing down the exposure settings.

I have referred to exposure values in terms of gray tones but the same rule applies for any color in the visible spectrum. For example, imagine you were photographing a blue sky in the early morning. An unadjusted meter reading would give you an exposure value equivalent to medium blue—a tone of blue you would expect to see at noon. However, in the early morning, the sky will appear much lighter.

TRYING IT FOR YOURSELF

If you want to put theory into practice, then try this simple test. On an overcast, dry day, place three pieces of card on the ground—one white, one black, and one medium-gray. Set the camera's meter to auto exposure and photograph each piece of card separately, ensuring they fill the entire frame. When you review the results, you will see that each photograph appears the same in tone—medium gray.

Now replicate the test, but this time add 2 stops of light to the indicated exposure when photographing the white card and take away 2 stops of light from the indicated reading when photographing the black card. Photograph the gray card at the indicated reading. When you review this second set of pictures, you will notice that each piece of card looks the same in the picture as it does in real life.

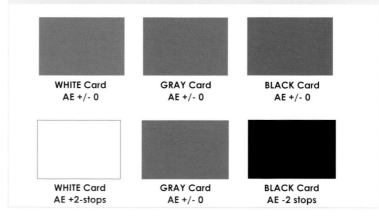

WHITE Card	GRAY Card	BLACK Card
AE +/- 0	AE +/- 0	AE +/- 0
WHITE Card	GRAY Card	BLACK Card
AE +2-stops	AE +/- 0	AE -2 stops

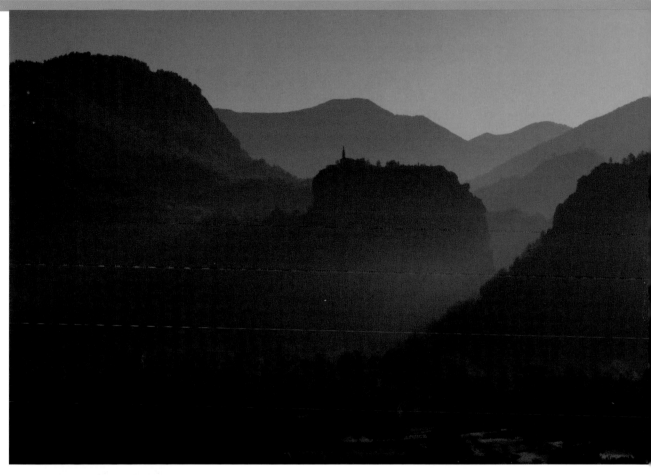

LEFT
This door is a middle-tone blue and so exposure was a simple task. I set the camera to spot metering and let it do the rest.

ABOVE
In complex lighting conditions, you need to take greater care over exposure decisions. Here I metered for the highlights to underexpose the shadow areas creating a dramatic silhouette.

ADVANTAGES OF TTL METERS

TTL meters are more practical than incident light meters because, since they are measuring light reflecting from a subject, there is no need to be in the subject's immediate vicinity. With TTL meters you also have the advantage that the meter will automatically take into account any light-limiting accessories in use, such as filters or high-magnification lenses.

Reflected light meters

The TTL meter in your DSLR measures exposure by assessing the amount of light actually reflecting from the subject directly through the lens. However, because the reflected light meter will be influenced by both highlights and shadows, as well as middle-toned subjects and everything in between, exposure calculations are often more complex.

In modern cameras, TTL meters now provide systems to help overcome this limitation. In the past, basic reflected light meters simply gave a meter reading based on an average of the entire scene. As technology has developed, however, more sophisticated systems have been developed.

Multi-segment metering (MSM)

MSM is a relatively new development in metering systems, and the technology is now so sophisticated that these systems are highly accurate, even under the most complex lighting situations. As its name suggests, an MSM system takes several independent readings from different areas of the frame and calculates a meter reading based on these. In some cameras, these findings are first compared to a database of "real-life" exposures to detect the closest match.

Center-weighted metering (CWM)

CWM is ideal for portrait photography because it measures the light across the entire scene but weights the light reading toward the level of brightness in the center of the frame. Usually around 75 percent of the reading is based on a half-inch circle in the center of the viewfinder.

DEPTH-OF-FIELD PREVIEW BUTTON

Some cameras have a depth-of-field preview button, usually on the front of the camera, that allows you to see exactly the depth of field in any given scene. This is one of the most useful features on a camera and is worth considering when choosing which model of DSLR to purchase.

LEFT
The wide subject brightness range in this image makes multi-segment metering a sensible option. Here it has produced a perfect exposure.

ABOVE
Center-weighted metering is often an appropriate choice of metering mode when photographing people, either in a studio or for candid photography.

OPPOSITE
I knew from experience that these garlics were around 1.5 stops brighter than middle-tone. I set the exposure compensation accordingly to capture an accurate image.

Spot metering

When set to Spot Metering (SM) mode, the TTL meter takes a reading from a tiny section of the scene—usually an area around just two to three degrees. This enables precise metering of specific areas and provides the greatest level of creative control over your exposure settings. SM is an ideal solution when working in high-contrast conditions and where the intensity of light varies throughout the frame.

Controlling exposure

Once you have determined the correct exposure value for the scene you're photographing, you must decide which combination of exposure settings to use. The two main controls available to set exposure are lens aperture and shutter speed. How you apply them will have an effect on the way the subject appears in the final image. You have to decide which of the two takes priority.

Lens aperture

All good pictures tell a story. What that story is will depend on where you place the emphasis in the photograph. For example, are you trying to give the subject a sense of place, or are you trying to place an emphasis on and to isolate a particular part of a scene? Whatever the answer, you must be able to control the camera to get the effect you want, and one of the mechanisms you have available to take control over the creative aspects of image-making is lens aperture. Lens aperture affects the amount of depth of field you have to work with, and depth of field influences the way you perceive a scene or subject by emphasizing certain areas (those that appear in focus) and isolating others (those that appear out of focus).

DEPTH OF FIELD

Depth of field is also affected by focal length and camera-to-subject distance. In order to calculate the exact depth of field, given all three variations, you need to refer to depth-of-field charts, usually provided with the lens.

OPPOSITE

Lens aperture is one of the components that affects depth of field. A narrow aperture was used here to render sharp the foreground and background detail.

ABOVE

For this picture, I took a spot meter reading from the red mailbox that I knew to be middle-tone.

LEFT

Here, I used a wide aperture to minimize depth of field.

EXPOSURE MODES

You also need to decide how you want to represent motion in your pictures, and motion is controlled by the shutter speed. A fast shutter speed will freeze the appearance of motion, giving the subject a sense of static. A slow shutter speed, on the other hand, will have the opposite effect, blurring the edges of the subject and creating a sense of movement. Compare these two images and note how changing the shutter speed affects the way the motion is recorded.

You need to be aware of the effects of using very slow shutter speeds (less than half a second) with digital capture. Unlike film, DPSs are unaffected by the failure in the law of reciprocity. However, at slow shutter speeds, the level of digital noise, visible in digitally captured images as unrelated pixels, increases. This noise will reduce image quality.

You can alleviate the problem to some extent by applying the Noise Reduction (NR) function from the menu options if your model features this useful function. The camera's processors scan the image for noisy pixels and alter the value of the pixel using data taken from adjacent pixels. For example, if the processors detect a single pixel with a value of 131 among a group of pixels all with a value of 23, it will be apparent that noise is present, and the pixel will be altered to 23. You can do the same thing using Adobe Photoshop but it will take you a long time to complete!

CSM MENU	
Exposure delay mode	**OFF**
Long Exposure NR	**On**
File no. sequence	**OFF**
Control panel / Finder	**»**
Illumination	**OFF**
Flash sync speed	**1/250**
Flash shutter speed	**1/30**
AA Flash mode	**On**

NOISE REDUCTION AND PROCESSING TIME

On some older DSLR cameras, the Noise Reduction (NR) function can take a long time to process, increasing image-processing time from one or two seconds to minutes. If this is the case with your DSLR, be sure to switch off the NR function once your shutter speeds reduce below half a second.

OPPOSITE
A slow shutter speed (1/30) has blurred the motion of this water cascading over the rocks, creating an atmospheric and moody image.

ABOVE
To freeze the motion of this hurdler, I set a fast shutter speed of 1/250. Notice that there is still some blurred movement in evidence.

EXPOSURE MODES

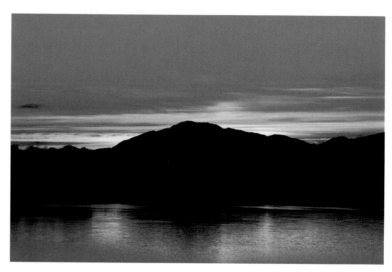

ABOVE, AND RIGHT

Because I was conscious of the need for an extensive depth of field, I wanted to retain control over lens aperture and set the metering mode to Aperture-priority Auto.

Which exposure mode you select will depend on the situation. For this landscape silhouette I decided to make my own exposure decisons and set the metering to manual.

EXPOSURE MODE	SYMBOL	LENS APERTURE	SHUTTER SPEED	USE
Variable Programmed Auto	P*	Set by camera for optimal size depending on the subject	Set by camera for optimal speed depending on the subject	Camera controls both lens aperture and shutter speed, but user can influence settings by indicating the type of subject being photographed
Programmed Auto	P	Set by camera	Set by camera	Camera controls both lens aperture and shutter speed, and user has no initial input. User can adjust the camera's chosen settings up and down manually before exposure, and camera will maintain correct combination of settings
Shutter-priority Auto	S or Tv	Set by camera	Set by user	When the user wants to control the shutter speed—e.g., to blur the appearance of motion or to freeze fast action, such as in sports and wildlife photography
Aperture-priority Auto	A or Av	Set by user	Set by camera	For controlling depth of field, often used in landscape photography, portraiture, and architectural photography
Manual	M	Set by user	Set by user	When the user wants to maintain complete control over both lens aperture and shutter speed. Useful in complex lighting situations

Preprogrammed exposure modes

Auto
The camera chooses the best combination of lens aperture/shutter speed, depending on the subject and lighting. Use in general "snapshot" photography.

Portrait
The camera chooses the best combination of lens aperture/shutter speed to soften and blur background details. Use for outdoor portraits and indoor portraits in good light. Use a short telephoto lens (70–100mm) for best results. If the subject is backlit or in shadow, use a flash unit to fill in the shadows.

Landscape
The camera chooses the best combination of lens aperture/shutter speed for great depth of field, making objects sharp both in the foreground and background, usually setting a narrow aperture. Use in landscape photography in good lighting. Use wide-angle lenses (17-24mm) for grand vistas and always support the camera on a tripod.

Close-up
The camera chooses the best combination of lens aperture/shutter speed to give vivid detail. Use when photographing very small subjects such as flowers, natural patterns, and insects. A macro lens will give the best results when photographing small subjects. Always steady the camera on a tripod.

Sports
The camera chooses the best combination of lens aperture/shutter speed to freeze motion, usually applying a fast shutter speed. Use when photographing sports, pets, young children, and fast-moving wildlife subjects. Use a medium telephoto lens (200–400mm) for best results with distant subjects.

Night landscape
The camera chooses the best combination of lens aperture/shutter speed to allow long time exposures. Use when photographing outdoor scenes in low light and at night, such as a cityscape. To avoid image-blur caused by camera shake, use a tripod and the self-timer or remote control device to fire the shutter. Also, turn on the noise reduction function (see page 75) in the menu options.

Night portrait
The camera chooses the best combination of lens aperture/shutter speed to allow an even balance between background and subject lighting. Use when photographing people in low light. To avoid image-blur caused by camera shake, use a tripod and the camera's remote-control device to fire the shutter.

As well as different metering modes, your DSLR is equipped with several different exposure modes. Typically, these will include Programmed Auto (often represented by the letter "P"); Shutter-priority Auto (represented by the letters "S" or "Tv"); Aperture-priority Auto (represented by the letters "A" or "Av"); Manual (represented by the letter "M"); as well as multiple pre-programmed modes, for example Sports Mode, Portrait Mode, and Landscape Mode. (Usually these preprogrammed auto-exposure modes are represented by simple graphic symbols.)

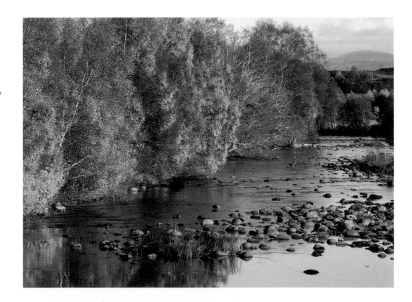

Programmed Auto mode

When set to Programmed Auto-exposure mode, the camera determines both the lens aperture and the shutter speed, giving you no control over either. This mode is suited to the novice photographer when first getting to grips with the camera and to photography in general. However, if your interest in photography develops beyond simple curiosity, then you are well advised to ignore this setting.

Pre-programmed Auto modes

Like Programmed Auto mode, preprogrammed exposure settings allow the camera to make the decisions when selecting lens aperture and shutter speed. However, these settings provide the camera with some information about the subject you're photographing, which enables it to make selections more closely appropriate to the conditions. For example, in SPORTS mode, your DSLR will set a relatively fast shutter speed since it assumes a fast-moving subject. In LANDSCAPE mode, it will select a small aperture ahead of shutter speed in order to increase depth of field.

While this mode provides a level of control over photographic technique, you are still ceding overall control to the camera, which, in turn, is making assumptions about the type of image you are trying to create.

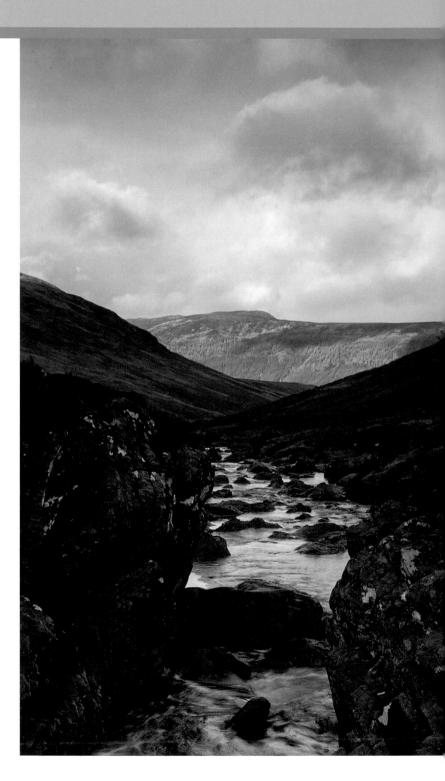

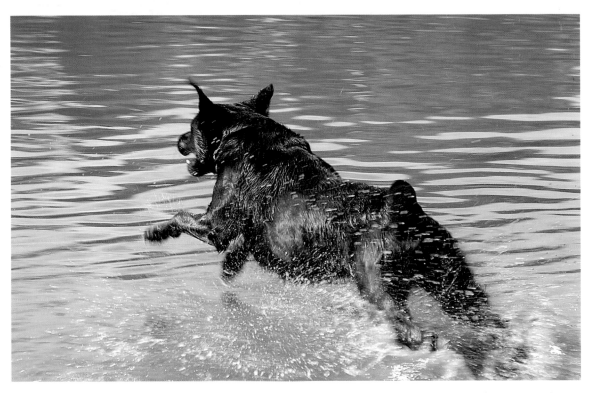

LEFT
When set to the pre-programmed LANDSCAPE exposure setting, the camera selects a narrow aperture to increase depth of field.

ABOVE AND RIGHT
When photographing animals, the preprogrammed SPORTS mode will select a fast aperture to freeze the appearance of motion.

Shutter-priority Auto mode

When you select Shutter-priority Auto mode, you select the shutter speed and the camera sets an appropriate lens aperture, based on the meter reading and any fine-tuning you have made to the exposure. This setting gives you control over how motion appears in the final image and is often the preferred exposure mode for sports photographers.

Aperture-priority Auto mode

In Aperture-priority Auto mode, you set the lens aperture and the camera sets an appropriate shutter speed depending on the conditions. Taking control over lens aperture gives you command over depth of field. This is my preferred setting for most of my photography, including wildlife.

OPPOSITE AND BELOW
In both of these images, shutter speed is the controlling factor. For the steam engine (opposite), I selected a slow shutter speed (1/30) to show detail in the revolving wheel. Conversely, for the photograph of the rapids, I used a fast shutter speed (1/300) to capture all the action.

EXPOSURE MODES

Manual mode

In Manual exposure mode, you retain control over both lens aperture and shutter speed. I prefer to use the camera in Manual mode for landscape photography, when I'm taking pictures of static subjects in complex lighting conditions. Manual mode gives you complete control over the picture-taking process and requires a full knowledge of how both lens aperture and shutter speed affect the outcome of your picture-taking.

While you may not use it all the time, the knowledge you will glean from learning how to use it will always complement your photography.

ABOVE
When photographing landscape scenes, I prefer to set the exposure mode to Manual.

RIGHT
You need quick-thinking to capture an image like this, and to anticipate the moment by setting up the camera to catch it.

OPPOSITE
It's usually best to set the camera to Manual when you're dealing with complex lighting in static landscape scenes.

Reciprocity law

The Law of Reciprocity as it pertains to photographic film relates to the theoretical relationship between the length of an exposure and the intensity of light. In effect, the increase in one can be balanced by an equal and opposite change in the other. For example, if you halve the amount of light reaching the film, you must double the length of time the film is exposed to retain parity. Conversely, if you reduce the length of time the film is exposed by one half, then you must double the intensity of light (via the lens aperture control). When using film, this law holds true at certain shutter speeds but fails during very long and very short exposures—referred to as reciprocity law failure. However, digital sensors are not affected in the same way and the Law of Reciprocity holds true.

FINE-TUNING EXPOSURE IN APERTURE-PRIORITY AUTO MODE

When applying exposure compensation or auto-bracketing in Aperture-priority Auto mode, the camera will automatically adjust the shutter speed, leaving lens aperture at the value set by the photographer.

When you take a meter reading, you must ask yourself the question, "Is the subject I am metering middle-tone, lighter than middle-tone, or darker than middle-tone?" If the subject is middle-tone (see the table, right), then the given meter reading will provide a technically accurate result. However, if the subject is lighter than middle-tone, then you must add light (open up the exposure), and if the subject is darker than middle-tone then you must subtract light (stop down the exposure).

Exposure compensation

How do you know how much exposure compensation to apply? The secret is in learning to see color in terms of gray, just as your camera does. Practice by taking a gray card out with you and comparing it to different colors that you come across. The chart, right, and some real-world examples will help.

Note: *These figures are based on my own tests and will vary depending on your camera. I always recommend running some tests of your own for greater accuracy.*

Backlit subjects

When you meter a scene where the subject is lit from behind (e.g., shooting into the sun), the camera's meter may be unduly influenced by the high level of contrast between the bright background and a subject in shadow. Often the result will be an underexposed subject. To counter this, you can either switch to spot metering mode and meter from the subject directly, or adjust the exposure setting (in this example opening up the exposure) by applying exposure compensation.

GRAYSCALE

Black Mid-tone(18%) gray White

−2 stops ±0 +2 stops

COLOR SCALE

Color		Example subject	Exposure compensation (stops)
	Black	Raven	-2
	Dark green	Conifer Evergreen tree	-1.3
	Dark brown	Wet earth	-1
	Mid-tone brown	Redwood tree	±0
	Mid-tone red	Poppies	±0
	Mid-tone green	Lawn Green field	±0
	Mid-tone blue	Blue sky around midday	±0
	Flesh	Palm of the hand	+1
	Light blue	Blue sky around 9 a.m.	+1
	Yellow	Daffodil Dandelion	+1.3
	Gold	Sand	+1.5
	White	Swan	+2.0

ABOVE
This table provides some of my exposure compensation values for different colored subjects.

LEFT
You can use exposure compensation to expose subjects that are backlit.

BELOW
To make sure that this candid image was correctly exposed, I added +1 stop exposure compensation to brighten the shadows on the subject's face.

SILHOUETTES

Use the same technique when creating silhouette images as for backlit subjects, except that you need to apply minus exposure compensation to darken the shadow areas to a point where no detail is visible.

BRACKETING

Hedging your bets

Whatever care you take when calculating exposure, it is sometimes impossible to get it absolutely right. Many factors can influence an exposure, such as very bright sunlight reflecting off shiny surfaces (e.g., water, sand, and glass); constantly changing light conditions, like those you will encounter on days when broken clouds fill the sky; and subtle variations in a subject's tonality.

Bracketing an image (taking more than one photograph of the same scene at varying exposure values above and/or below your initial exposure setting) will help ensure you get an accurate result in difficult lighting conditions. Compare the three images shown here. The lighting conditions were variable and the subject has a wide range of tones. The first is shot at the camera's

indicated exposure setting with two further frames at +1/2 stop and −1/2 stop. In this case, the extra 1/2 stop created an overexposed image, the -1/2 stop image was slightly underexposed, and the original reading turned out to be the most accurate. There may be occasions when opening up or stopping down slightly will give you a more accurately exposed result.

THE LCD SCREEN AND EXPOSURE

From experience, I have found the LCD screen on digital cameras alone to be an unreliable measure of exposure. To assess exposure accurately using the LCD screen, use the histogram function (see page 88).

These three images show the effect of bracketing exposures. The first image (top) was shot at +1/2 stop from the meter reading, the image right at −1/2 stop from the meter reading, and the third image (above) with no adjustment. In this instance, the original meter reading (above) was the most accurate of the three.

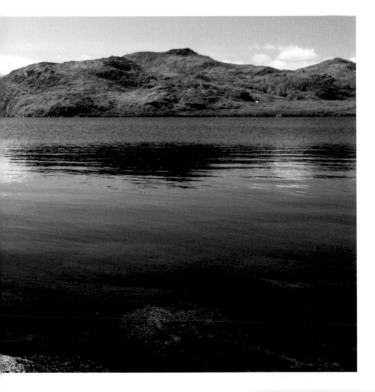

THE CASE FOR BRACKETING

Because the LCD screen allows for instant replay of images, it is arguable that bracketing is no longer necessary. However, even with digital technology, bracketing has a role to play. For example, if you are photographing a fast-moving subject, such as motor sport or wildlife, time doesn't always allow you to check the exposure on the screen and then go back to reshoot if the resulting image is less than perfect.

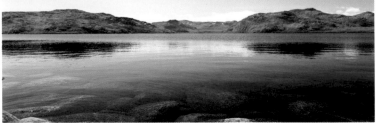

THE HISTOGRAM

Reading the histogram

The digital histogram is, to all intents and purposes, a bar chart. The horizontal axis represents levels or tones of gray, from black (left) to white (right). The vertical axis represents the quantity of pixels of any given tonal value. The histogram, therefore, can be used to determine whether an image is accurately exposed.

The data provided by the histogram must be read with caution, for two main reasons. First, if you are photographing a high-key image,

a low-key image, or a silhouette, then it is entirely reasonable for the histogram to show a skew towards one end of the tonal range. More importantly, the histogram on the camera represents processed image data, i.e. data reflective of a JPEG image. If you are shooting in JPEG mode, this is fine; however if you are shooting in RAW mode the data provided by the histogram (and this also applies to the preview image displayed by the LCD screen) will be inaccurate and unreliable.

The benefit of this tool is in determining accurate exposures. The example below shows a picture that is overexposed. The majority of pixels are on the right of the histogram with a large number in the 255 value (white) end and very few pixels to the left of middle-tone (with none in the black end). Looking at the histogram and comparing it with the relevant image, you can see that the photograph is overly bright, and overexposed.

THE PERFECT HISTOGRAM

There is no such thing as the "perfect" histogram, but the well-exposed image (opposite, bottom) has an example that is generally what you should be aiming for. There is a reasonable spread of tones from shadow to highlight and the bell of the curve is very slightly to the left of center.

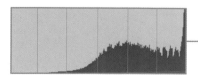

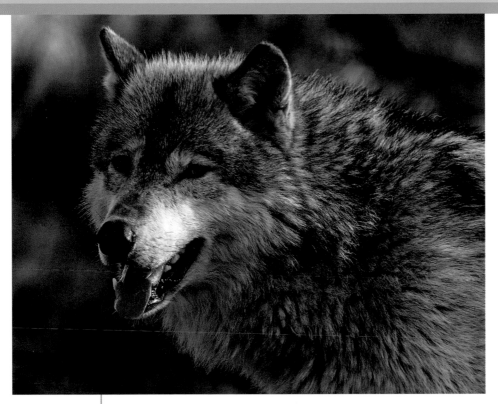

BOTH PAGES
Compare these three images and their respective histograms. The image opposite is overexposed and the histogram shows a skew to the right. The picture left is underexposed and the histogram shows a skew to the left. Finally, the image below is well exposed and the histogram shows a balanced, bell-shaped curve.

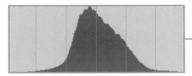

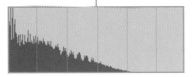

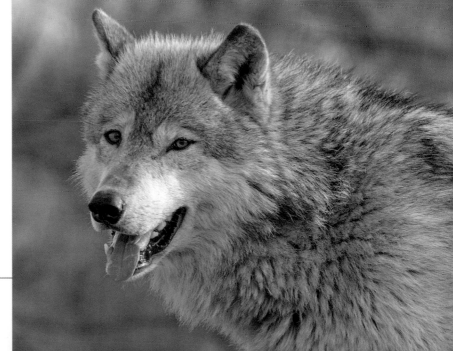

THE HISTOGRAM

The histogram below (bottom) indicates a picture that is underexposed. The majority of pixels are on the left of the histogram (which represents the shadows and darker tones of the image) and, apart from one distinct spike, very few pixels lie to the right of the middle-tone (with none at the highlight end). When you compare the histogram with the accompanying image, you can see that the photograph is very murky, flat, and underexposed.

In the example above it, however, the information shown in the histogram indicates a much better exposure, where there is a good spread of tones between the black and white points, and the majority of pixels within the latitude of the sensor. Looking at the image associated with this histogram, you can see a good level of contrast, with strong detail in both the shadow areas and in the highlights.

Raw histograms

When shooting Raw, the histogram the camera displays is actually that of an in-camera JPEG, and often when the histogram indicates that the highlights are overexposed this may not actually be the case with the Raw file. Use the highlight warning display to check that highlights really are actually blown if this happens.

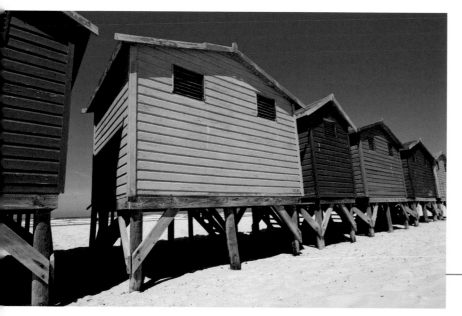

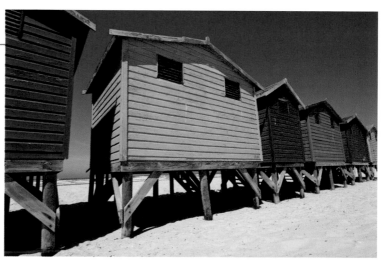

TOP
This image has a good spread of tones, from the shadows on the sides and under the huts to the brightly lit sides facing the camera. The associated histogram reflects the even spread of tone.

RIGHT
This image is badly underexposed, as shown by the left-leaning histogram and nothing registering in the highlight area.

ABOVE
This colorful scene is a good example of how a well-exposed image should look: vibrant white in the paintwork, deep shadows in the interiors, a scarlet red, and a brilliant blue— a perfect spread of tones from black to white, with strong middle-tones.

VARIANCES IN HISTOGRAM DISPLAYS

You will notice that the histogram of a single image varies between the camera and software applications such as Adobe Photoshop. This is caused when the software converts the digital original into its own color space, in which individual pixel values may be altered.

Tackling overexposed areas

As well as the histogram, many digital cameras have a function that identifies areas of the image that contain burned-out highlights (i.e., areas that have no data value and will appear as detail-less white).

This feature helps identify areas of extreme overexposure and can be utilized when you are photographing in complex lighting conditions and are uncertain whether the subject brightness range is within the latitude

of the DPS. If a significant section of the image space is highlighted as being burned out, then consider adjusting your exposure settings or utilize light-limiting filters, such as graduated neutral density filters.

ABOVE
A high level of reflected light in this vehicle's headlight has caused the brightest area of the scene to grossly overexpose, or burn out.

OPPOSITE
After checking the highlights screen (top), and by adjusting the exposure accordingly, I managed to expose more accurately (right).

OVER- AND UNDEREXPOSURE

In digital photography, if it's a choice between the two alternatives, it's better to slightly underexpose an image than to overexpose. This is because burned-out highlights contain no data value at all, and so nothing exists that is adjustable in image-processing software, while even the darkest shadow areas have image data that can be manipulated in-computer.

Handling the camera

The fundamental principles that govern handling a camera successfully in the field vary little between film and digital cameras. Indeed, the controls of a digital camera from an individual manufacturer are often placed identically on the camera bodies, making switching between the two media a relatively simple process.

Some cameras have the commonly used functions accessible via buttons and dials on the camera body, while others hide them within the menu options. I prefer the former because it speeds up the image-capture process—it's a lot easier rotating a dial than navigating across and down menu bars. After years of using a Nikon F5 as my main camera body, I have also found that I prefer to work with a camera that has a substantial feel to it.

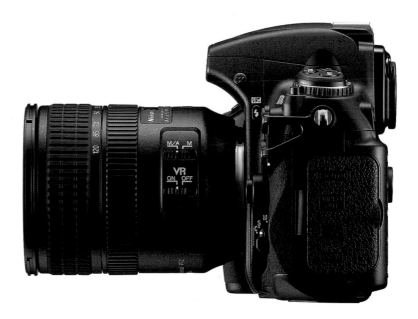

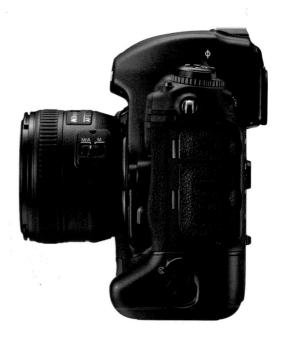

ABOVE
The compact and light Nikon D700 features an array of buttons and dials on the camera body for fast access to most of the image controls while shooting.

RIGHT
The Nikon D3S incorporates optimized button placement and a molded grip, making it easy to hold the camera steady. It is an ideal choice for photographers working under difficult conditions.

When hand-holding the camera is the only option, hold the camera body with your right hand, the thumb at the back, and the forefinger on the shutter release. With your left hand, support the lens by the lens barrel. Keep your feet slightly apart and your arms close to your body. For extra stability, lean up against a solid support, such as a wall, or lower your center of gravity by kneeling or lying down.

When the time comes to take the picture, take a deep breath and release the shutter as you're breathing out. This is when your body is at its most relaxed.

BELOW
A low center of gravity and holding the camera in a well-balanced manner will help keep images sharp and free of blur from camera shake when hand-holding is the only option.

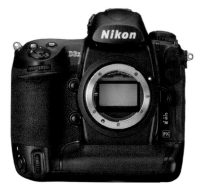

ABOVE
Be aware of the impact of dust on the DPS when changing lenses on a digital camera, and avoid leaving the camera body for long periods without a lens or body cap attached.

KEEPING DUST AT BAY

If possible, change lenses in a clean plastic bag, such as a trash sack. This will help prevent exposing the camera to dust when it can be easily avoided — at a fraction of the cost of fixing the damage. For more on this, see page 99.

Shutter lag

I will mention shutter lag although it is something you really won't need to worry about. Many digi-skeptics flagged shutter lag as one of the disadvantages of digital cameras, and while this can be the case with less expensive, consumer-spec digital compact cameras, it is not a factor when it comes to digital SLR cameras. All cameras, including film cameras, have a certain degree of lag between pressing the shutter and the actual operation of the shutter. However, in modern cameras this time lapse is so insignificant (for example, in my Nikon D2H it is a mere 37 milliseconds) as to be irrelevant except for the most exceptional of photographic applications.

Mirror lockup

The mirror lockup on most DSLRs is not the same as the mirror lockup function on a film camera, where it is used to manually lock the mirror in the up position before the shutter activates in order to reduce the likelihood of vibrations causing image blur.

On a digital camera, this function is used to lock the mirror out of the way of the low-pass filter when cleaning the DPS of dust and dirt.

A similar, albeit electronic, version of mirror lockup on a film camera is possible with some DSLRs and is sometimes referred to as anti-shock mode.

RIGHT
A tripod is the most stable form of camera support. Make sure that the model you choose is designed to carry the weight of your heaviest camera/lens combination.

Changing lenses

My main concern when changing lenses is to avoid dust entering the camera body and attaching to the low-pass filter that sits in front of the DPS. Dust is a major hazard in digital photography, far more so than it ever was with film cameras.

Dust is attracted by the electro-magnetic properties of a DPS and will appear on your images as dirty marks or dark specks, as the dust particles completely or partially block light from reaching the light-sensitive photodiodes.

Regular cleaning is possible, and often essential, but prevention is better than cure. Always remove the lens with the camera body facing down—not the simplest of tasks but one worth practicing. Make the changeover a quick process, and avoid leaving the lens-mount aperture exposed to the air for any length of time.

Finally, consider using zoom lenses, which give you greater flexibility in selecting focal length and negate the need for frequent lens changes.

LEFT
Dust and dirt residue on the DPS or low-pass filter will show up as marks on your digital image, as shown here. Minimize the opportunities for allowing dust to enter the camera chamber by changing lenses in clean environments whenever possible. If dust and dirt become a problem have the DPS cleaned, (see pages 12-13).

Defining the picture space

As well as allowing you to see what the camera is seeing, the viewfinder is a frame that defines the edges of the picture space. The picture space performs the same function as an artist's canvas—it is the area within which you create the image, and using it effectively will improve the composition of your photographs.

Frame format

First, you need to consider in which format you're going to photograph —vertical or horizontal. Both formats are equally valuable but emphasize the subject differently. For example, in the vertical position, emphasis is

given to height, which can be used to accentuate tall structures. Conversely, in the horizontal format, the accent is placed on space, which can be exploited well by landscape photographers, for example.

Subject positioning

How you position the main subject within the frame will affect its visual presence. There are two choices— center or off-center. A widely used compositional technique is the Rule of Thirds. The principal behind this rule is to divide the picture frame into

thirds by drawing across it imaginary vertical and horizontal lines at one-third intervals (see right). The focal point of the image can fall at one of the intersections.

LEFT
By using the camera in the vertical format, I have accentuated height in the picture space.

BELOW
Switching to the horizontal format has altered the emphasis of the picture completely. Now there is a greater feeling of space and an increased sense of place.

OPPOSITE
Using the Rule of Thirds (illustrated in the diagram below) in the composition of this picture has given it much greater dynamic visual weight than merely centering the image.

RIGHT
Here, a centrally positioned subject has placed the emphasis on the shutter and rendered the unimportant wall secondary to the image.

BELOW
The Rule of Thirds divides the frame into a grid of thirds, and says that the focal point of any image can fall at any one of these intersections.

Alternatively, positioning your subject in the middle of the picture space will isolate it from the surrounding area and hold your gaze on the center.

Symmetry and asymmetry can then be used to dictate the visual weight of your pictures. A balanced (symmetrical) picture tends to create a sense of serenity and/or solidity, while an unbalanced (asymmetrical) image will appear more dynamic.

ABOVE
The asymmetrical composition used here has created a dynamic image full of visual energy.

RIGHT
Symmetry can be used to create a more calming composition, as this image illustrates.

TOP FIVE TIPS FOR COMPOSING A PICTURE

1. Use converging lines to give your pictures a sense of depth.

2. Position complementary colors adjacent to each other, particularly red and green, to give images a three-dimensional feel.

3. Color can be used to set the mood of a picture. For example, bold colors are punchy and create tension; red and orange will give images a warm overtone, while blue will make a scene appear cold; pastel colors are more soothing.

4. Use different focal-length lenses to alter your perspective. You'll be amazed how a plain subject can be revitalized when looked at from an unusual perspective.

5. Don't position the main subject at the very edge of the picture space. Give it some room to breathe.

THE FLOW OF GRAPHIC ELEMENTS

In the Western world, we read from left to right and from top to bottom. When the flow of graphic elements mirrors this orientation, the resulting image is more pleasing to the eye.

ELECTRONIC GRID LINES

Some DSLRs (e.g., the Nikon D100 and D70) come equipped with an electronic grid display that can be turned on and off via the menu options. I have found this option particularly useful when photographing landscapes, and the display is considered essential by architectural photographers.

VIEWFINDER COVERAGE

Few DSLRs provide 100 percent viewfinder coverage; most cover around 95 percent of the actual picture space. If this is the case with your DSLR, then remember to check the outlying area for compositional considerations before taking the picture.

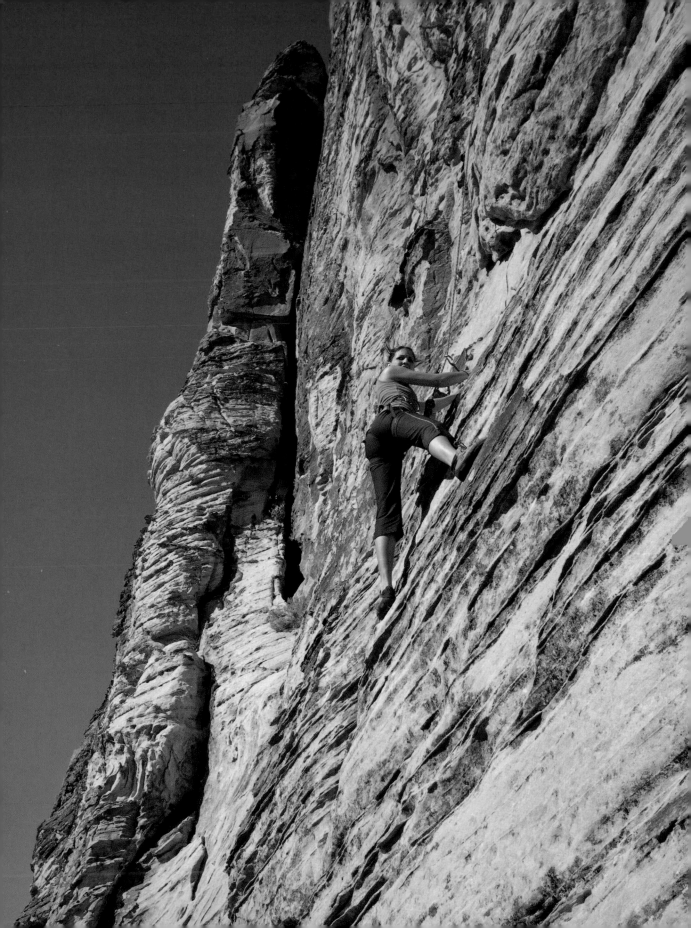

Autofocus

Most DSLR cameras come equipped with autofocus (AF). In AF mode, the camera uses one or more manually selectable AF sensors, visible in the viewfinder, to detect camera-to-subject distance and set focus distance accordingly. The number of AF sensors varies with the camera model, but usually they include a minimum of five (top, bottom, left, right, and center) and a maximum of 11. The greater the number of sensors, the more accurate the AF system should be, particularly when continuous-servo (AI servo) mode is used. With the exception of the center sensor, the additional sensors also help the camera accurately focus on off-center subjects when operated in AF mode.

Selecting the appropriate AF sensor

When focusing on a subject in AF mode, select the AF sensor that most closely matches the position of the subject in the viewfinder. If the subject falls outside of the AF sensors' target area, then first position the sensor over the subject to attain focus. Then lock focus using the AF LOCK button (most cameras will lock focus when the shutter-release button is pressed halfway down and single-servo AF mode is selected), recompose, and take the picture.

OPPOSITE
To attain accurate focus, ensure that the active AF target sensor covers the subject when framed in the viewfinder.

ABOVE
This illustration shows the positioning of the AF target sensors on the Nikon D2H.

NOT ALL AF SYSTEMS ARE CREATED EQUAL

The three basic requirements of an AF system are that it is fast, accurate, and reliable. The systems built into professional-specification cameras, such as the Nikon D3s and the Canon 1DS, are far superior to those used in prosumer cameras, such as the Nikon D90 and the Canon 1100D.

Single-servo mode

In single-servo AF mode, the camera first detects the point of focus and then locks focus until the shutter is fired or the shutter-release button is pressed. If the subject moves, the camera will not alter the focus distance and the subject becomes out of focus. In this setting, priority is usually given to focus, and the shutter will only activate once focus is locked. Typically, you would use single-servo AF mode for static subjects, such as landscape scenes, still life, and architectural photography.

Continuous-servo mode

When continuous-servo (sometimes referred to as AI servo) AF mode is selected, the camera will detect focus but focus remains unlocked. If the subject moves away from the point of focus, the AF system will track the movement of the subject within the picture frame, adjusting focus distance as necessary, even if the subject is temporarily obscured. Priority is usually given to the shutter, which will activate whether or not the subject is in focus. This is an ideal setting when photographing fast-moving and erratic-moving subjects, such as those found in sports and wildlife photography.

CLOSEST-SUBJECT AF

Closest-subject AF mode is one of the newer functions to have appeared on DSLR cameras. The principle is that the AF sensor detects the subject closest to the camera and focuses on that subject. It is most often selected when the camera is being used for point-and-shoot photography because it is reliable and can speed up picture taking. However, it is less useful when you want to maintain a greater degree of control over the camera; in this case, basic AF or manual-focus modes should be selected.

BELOW
Continuous-servo AF mode is ideal for photographing moving subjects.

OPPOSITE
Single-servo AF mode is suitable for static subjects.

Manual focus

There are times when AF will be unreliable or simply less convenient. For example, when photographing wildlife in dense vegetation, foliage can obscure the subject, and I often find that the AF system gets caught up "hunting" (adjusting focus distance without ever attaining correct focus), so I waste precious time and sometimes lose the shot altogether.

Also, when shooting landscapes, I see little need to waste battery power by using AF. On such occasions, I switch to manual focus, using, when necessary, the electronic focus indicator in the viewfinder to clarify when correct focus is attained.

PREDICTIVE-FOCUS TECHNIQUE

Another focus technique you can use is predictive focus, suitable when photographing moving subjects with a known line of travel between two points.

To use predictive focusing in Manual-focus mode, first focus on a point along the line of travel where you will take the picture. Then frame the subject in the viewfinder and follow its progress with the camera. Just before it reaches the predetermined focus point, activate the shutter (with shooting mode set to continuous) and keep the camera exposing images until just after it passes. So long as you have at least one exposure in which the subject intercepts the point of focus, you will have one sharp image for the album.

LEFT
Dense foliage made AF impractical for this image. I switched to manual mode and focused the old-fashioned way!

Focus and image sharpness

There is only ever a single point of focus in photography, and anything in front of or beyond that point is out of focus. The question is whether or not it appears sharp. Sharpness is subjective and depends on a number of variables, including the health of our own eyesight, the physical size of the photograph, and the distance from which it is viewed. Technically, sharpness is determined by the distance between image-forming

points, known as the circle of confusion. Effectively, the human eye is incapable of determining detail smaller than a certain size (around 4/1,000in). For example, if you look at a 10 x 8in print made from a full-frame DPS, you will be unable to distinguish two adjacent points less than 1/10,000in in size and, therefore, they will appear sharp.

BOTTOM
With a small aperture of f/16 (for example) there is a smaller circle of confusion between a near and a far subject in terms of the image appearing sharp. Widen the aperture to f/5.6, for example, and the circle of confusion is larger.

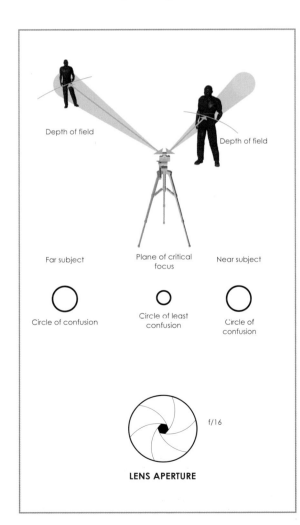

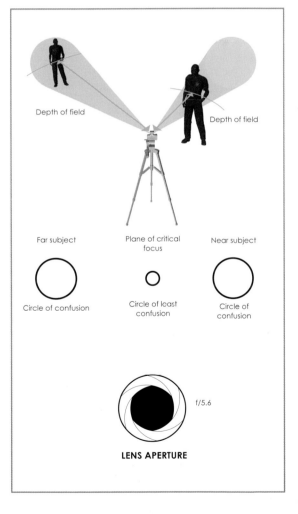

DEPTH OF FIELD

Aperture and focal length

The point either side of the point of focus that appears sharp is known as the depth of field, which is determined by lens aperture, focal length, and camera-to-subject distance. Depth of field is minimized when using telephoto lenses, when the subject is close to the camera, and when large apertures are set. To maximize depth of field, use short focal-length lenses, stand back from the subject, and select a small aperture.

Managing depth of field is a critical element in photographic composition. The proportion of the scene that appears sharp will determine the visual presence of the photograph.

For example, a shallow depth of field will help isolate the subject from the background by removing any other pictorial distractions. On the other hand, rendering the whole scene sharp will give your subject a sense of place by including information about its environment.

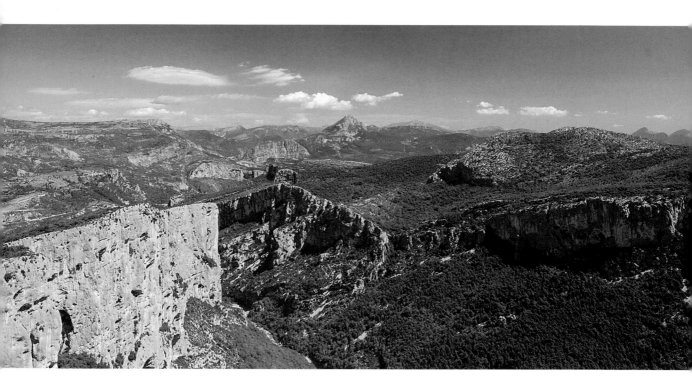

ABOVE
In most landscape photography, foreground-to-background sharpness is critical to the success of a picture.

OPPOSITE (FAR RIGHT)
A large aperture setting has created a shallow depth of field in this food shot.

OPPOSITE (NEAR RIGHT)
This illustration shows the relationship between depth of field and lens aperture, focal length and camera-to-subject distance. Depth of field is increased with small apertures (top), short focal-length lenses (middle), and when photographing distant subjects (bottom).

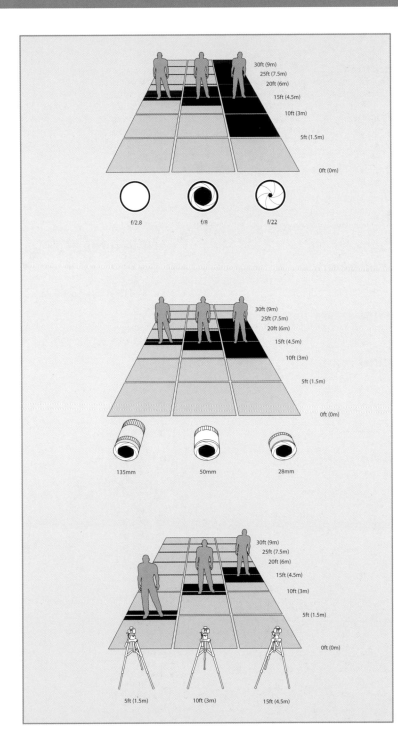

30ft (9m)
25ft (7.5m)
20ft (6m)
15ft (4.5m)
10ft (3m)
5ft (1.5m)
0ft (0m)

f/2.8 f/8 f/22

30ft (9m)
25ft (7.5m)
20ft (6m)
15ft (4.5m)
10ft (3m)
5ft (1.5m)
0ft (0m)

135mm 50mm 28mm

30ft (9m)
25ft (7.5m)
20ft (6m)
15ft (4.5m)
10ft (3m)
5ft (1.5m)
0ft (0m)

5ft (1.5m) 10ft (3m) 15ft (4.5m)

DEPTH OF FIELD AND LENS APERTURE

You can control the extent of depth of field (deep or shallow) using the lens aperture. A small aperture (large f/number) will increase depth of field because it reduces the size of the points that form the image outside of the focal plane. Conversely, a large aperture (small f/number) will reduce depth of field because the image-forming points are enlarged with every increase in aperture.

Maximum depth of field

Hyperfocal distance is the point of focus that gives the maximum depth of field for a given combination of lens aperture, focal length, and camera-to-subject distance. For example, if you focus the camera on infinity, depth of field will extend from somewhere in front of the point of focus—known as the hyperfocal distance—to infinity. If the hyperfocal distance is 50ft and you keep the lens focused on infinity, then your total depth of field is 50ft to infinity.

However, if you refocus the lens to the hyperfocal distance (i.e., 50ft in this example), depth of field will increase to half of the hyperfocal distance to infinity. So your new depth of field (the maximum achievable) will be from 25ft to infinity.

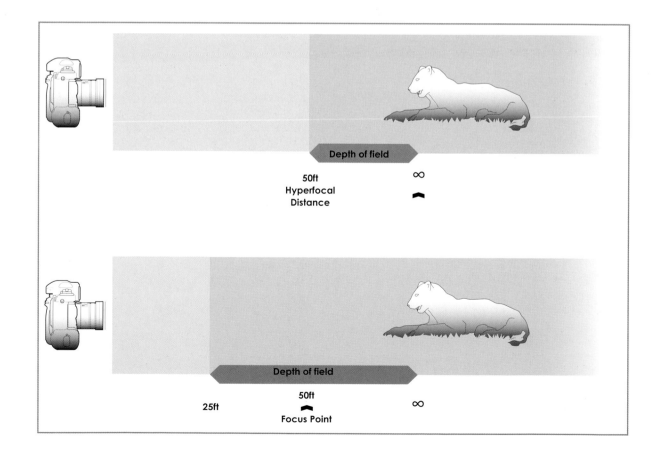

LEFT
With your camera
focused on infinity,
you have a short
depth of field (top);
the depth of field with
a focus set from 50ft
to infinity (bottom).

ABOVE
In this image the
depth of field extends
from near the camera
to infinity.

The LCD screen

All digital cameras have a rear LCD screen that, among other things, displays the images stored on the memory card. These screens vary in size, depending on the camera, and range from relatively small to approximately 3 inches. When I switched from my Nikon D100 to the D2H, one of the first things to strike me was the comparative enormity of the LCD screen on the new camera. Bigger certainly is better.

The ability to review each image immediately will help improve your hit rate of successful pictures, and while some quality checks can be made reliably only on a PC or Mac, there are certain checks you should make when the picture is all-important.

Perhaps the most useful feature of digital photography is the ability to review your pictures instantly. In the past, professional photographers used Polaroid instant film cameras to achieve the same thing: they took test shots of a scene and made any necessary adjustments to camera controls or lighting before they produced the actual image. Digital photography simply makes this process far more convenient.

USING THE LCD SCREEN OUTDOORS

It is notoriously difficult to view the information on an LCD screen when outdoors. One simple and inexpensive solution is to carry with you the cardboard tube from a roll of toilet tissue. Flattened down, it slips nicely into a pocket, and once restored to its normal shape, shades the screen for effective viewing in any lighting conditions. It is certainly a low-cost solution!

IMAGE-QUALITY PARAMETERS

There are some image quality parameters that can only reliably be assessed when the image is displayed on a comparatively large, high-quality computer monitor. These include color, saturation, tone, and absolute sharpness.

THE LCD PLAYBACK CHECKLIST

1. Check the strength of the composition: is it compelling or would changing camera angle, perspective, or focal length improve the image?

2. Check for clutter in the picture space: are there too many competing pictorial elements, and did you miss that electrical pylon taking center stage in the background?

3. Check for sharpness: not always easy to tell absolutely, but shots that are obviously out of focus will stand out.

4. Check for exposure: avoid relying on the on-screen image and switch on the histogram if your camera has this feature (see page 88) to assess brightness levels and tonal range, and make adjustments where necessary.

5. Check for highlights: are any large areas of the picture space burned out? If so, consider adjusting your exposure or applying light-limiting filters.

RIGHT
The ability to shoot and review your pictures is unique to the digital realm. It is a boon for the amateur photographer, but for the professional working in the field it is a godsend, offering not just enormous savings on film and development, but also the ability to revise a shot before it is too late.

Deleting images

Because I have been a professional photographer for many years, I can usually tell if an image has worked. I tend to delete the bad shots as I go along, which frees up space on the memory card and reduces the workload back in the office.

If you are just starting out in digital photography, I would recommend that you keep all your shots, including those that you think are no good, and review them on a computer monitor at home. This will help build your confidence in using the LCD screen for in-the-field editing.

You'll probably notice that the shots you were unsure about in the field need deleting, but it's better to be safe than sorry—and this technique is an excellent way of honing your editing skills.

IMAGE MAGNIFICATION

When reviewing images in the field for sharpness, I recommend using the magnification function to increase the size of the picture to the maximum possible. Composition, on the other hand, is best reviewed with the image unmagnified.

TOP
The image-magnification function is valuable for previewing images to check their sharpness.

BELOW
Being able to delete images is a double-edged sword: you can save memory by junking shots, but be sure you won't regret it later.

RIGHT
With so many in-camera functions available at the touch of a button, the advantages provided by digital technology are obvious.

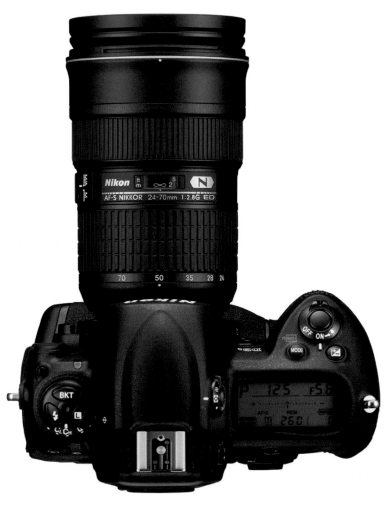

No film record

Some people may dislike the idea of not having a hard copy original of their favorite images—for instance, a slide or negative. There's not much you can do about this. On the plus side, working digitally cuts down on the storage space you need, and it is far easier to locate and track images in digital format than it is with slides or negatives. It is possible to have a transparency created from a digital file, but realistically this is far too expensive to consider as a viable option in most cases. Besides all this, it is becoming increasingly difficult to buy film stock as readily as one could in the past. It is very unlikely that film will disappear altogether, at least in the near future anyway, but it will become a more specialist commodity over time.

Learning curve

Because the digital camera body has far more functionality than its film counterpart, there is more to learn about its use. Rather than being steeper, the learning curve in digital is simply longer the more sophisticated your photography becomes. However, at the same time, the digital camera can be an aid to improving your skills and techniques rather than a barrier. And like most computers, the full extent of their functionality often remains unused in their lifetime—so don't be put off by features that have no relevance to your own work.

PROTECTING IN-CAMERA IMAGES

If you've managed to snap that award-winning image, then I would advise protecting it in-camera using the PROTECTION button. You don't want to delete it by mistake!

LEARNING FROM MISTAKES

If you're new to photography, it is worth keeping some of the poor images so you can assess them later and identify the reasons why they are pictorially unappealing. You will often learn more by studying a poor picture than you will by examining a good one.

ABOVE AND LEFT
Rolls of film have their attractions for enthusiasts and professionals, but this quantity will produce only a small fraction of the images that you can store on memory cards, or on a computer, using a digital SLR.

Getting the most from your batteries

Digital cameras are computers, and since the introduction of technologies such as AF and optical stabilization— VR (Nikon); IS (Canon); OS (Sigma)— cameras have become increasingly power hungry. This means that batteries are, more than ever, an essential item for the modern photographer.

Battery technology itself has developed over the years, and modern DSLRs use specially designed, rechargeable lithium-ion batteries that last longer than generic cell batteries, do not suffer from the "memory effect" of older rechargable battery technology so can be topped up regularly, and have a slow loss of charge when not in use.

There are some things that you can do to improve the performance of your batteries when using a DSLR. First, only power on those things that are vital to photographing a given scene. For example, if you have an image stablizing lens, only enable the functionality when you really need it.

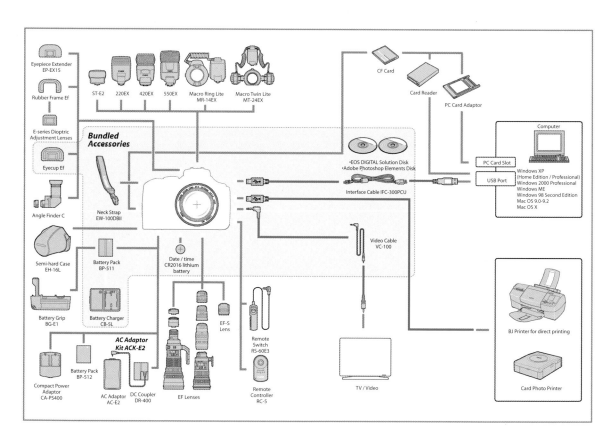

ABOVE
Cameras have always had interchangeable elements, such as lenses, filters, and accessories. But DSLRs are much more than that. Like all computerized devices, your camera is at the center of a matrix of interconnected devices and peripherals. Even the humble battery pack can, on some models, be available as a different kind of camera grip for ease of use in the field.

Optical-stabilization technology is largely redundant if the camera is set on a tripod (in fact, it can even degrade image quality), so I turn it off when shooting still life or landscapes. In addition, I can see little reason for using AF when photographing landscapes, so I normally switch to Manual-focus mode. In the boxes opposite are a few more tips on getting the most from your battery and preserving its life.

CHARGING BATTERIES ON THE MOVE

When shooting in remote locations, where power sources are unreliable, I use a device known as an inverter. This simple and inexpensive bit of kit connects to the cigarette lighter socket or 12v power outlet in your vehicle, allowing you to plug in a mains device that is then powered from the vehicle's battery.

TOP
Investing in a simple charging device that works with the 12v power in your vehicle is well worth considering.

BOTTOM
Modern battery technology has improved performance. Li-ion batteries like the one shown here have a far greater life span than cell batteries.

AVOID GETTING CAUGHT OUT

I always carry at least one fully charged spare battery with me in the field, and since switching to digital I have never had a camera run out of battery power.

PRESERVING BATTERY LIFE

1. Minimize the length of time camera settings are displayed on the control panel.

2. Switch off the PLAYBACK ALL function in the menu options and play back only selected images.

3. Download images from the camera to a computer using a mains adapter.

4. Use the appropriate AF setting for the subject.

5. Turn the camera off during periods of prolonged non-use.

6. Minimize the length of time that images are displayed on the LCD panel.

7. Manage image editing in-computer or with the camera powered by a mains adapter.

8. Always start out with a fully charged battery.

ADVANCED SHOOTING TECHNIQUES

Using the histogram to select tone (contrast) adjustment

As well as illustrating exposure, the histogram provides a useful visual aid for assessing the level of contrast. Because the histogram shows the range of tones present within an image, a chart that shows a lack of pixels at the extremes of the horizontal axis black (left) and white (right), also indicates a lack of contrast. For example, I shot the first picture opposite on a recent trip to France. On reviewing the initial result using the LCD screen, I felt it lacked contrast; I quickly checked the histogram, which confirmed my instincts. In this instance, I increased the level of tone in-camera and reshot.

Digital photography in low light

Digital cameras are not best designed for long time exposures. Whereas film will happily record light without any visual detrimental effect for several hours, the longer a photosensor is exposed to light, the more time it has to reveal its flaws. Essentially, these flaws show up as digital noise, caused either by heat (long time exposures greater than 1/2 second) or amplification (fast ISO-E ratings). The result, unless you are trying to achieve a particular artistic effect,

DSLR PREPROGRAMMED EXPOSURE MODES: AUTO	
Exposure Settings	The camera chooses the best combination of lens aperture/shutter speed depending on the subject and lighting.
Use	General "snapshot" photography.

PORTRAIT	
Exposure Settings	The camera chooses the best combination of lens aperture/shutter speed to soften and blur background details.
Use	Outdoor portraits and indoor portraits in good light.
Tip	Use a short telephoto lens (70–100mm) for best results. If the subject is backlit or in shadow, use a flash unit to fill in the shadows.

LANDSCAPE	
Exposure Settings	The camera chooses the best combination of lens aperture/shutter speed for great depth of field, making objects sharp both in the foreground and background, usually setting a narrow aperture.
Use	Landscape photography in good lighting.
Tip	Use wide-angle lenses (17–24mm) for grand vistas. Always support the camera on a tripod.

CLOSE-UP	
Exposure Settings	The camera chooses the best combination of lens aperture/shutter speed to give vivid detail.
Use	Photographing very small subjects, such as flowers, natural patterns, and insects.
Tip	A macro lens will give the best results when photographing small subjects. Steady the camera on a tripod.

SPORTS	
Exposure Settings	The camera chooses the best combination of lens aperture/shutter speed to freeze motion, usually applying a fast shutter speed.
Use	Photographing sports, pets, young children and fast-moving wildlife subjects.
Tip	Use a medium telephoto lens (200–400mm) for best results with distant subjects.

NIGHT LANDSCAPE	
Exposure Settings	The camera chooses the best combination of lens aperture/shutter speed to allow long time exposures.
Use	Photographing outdoor scenes in low light and at night, such as a cityscape. To avoid image blur caused by camera shake, use a tripod and the self-timer or remote-control device to fire the shutter.
Tip	Turn on the NOISE REDUCTION function (see page 60) in the menu options.

NIGHT PORTRAIT	
Exposure Settings	The camera chooses the best combination of lens aperture/shutter speed to allow an even balance between background and subject lighting.
Use	Photographing people in low light. To avoid image blur caused by camera shake use a tripod and the remote control device to fire the shutter.
Tip	Turn on the noise reduction function (see page 60) in the menu options.

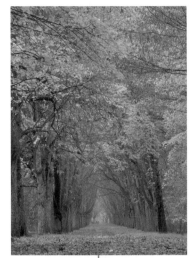

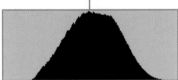

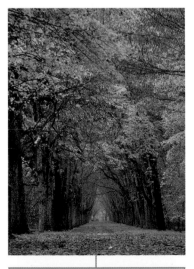

is to degrade image quality in a similar way to the effects of film grain (although this has its proponents). So, if you want to take pictures at night, what's the solution? The first step is to get an effective balance between ISO-E rating and shutter speed. For example, a slow ISO-E will reduce levels of amplification but will require slower (longer) shutter speeds, increasing heat-generated noise. Conversely, a faster ISO-E rating will reduce shutter speed (reducing heat-generated noise) but increase amplification levels and amplification noise along with it. It's a conundrum!

From experience, I would first use a speed below 400. Somewhere between ISO-E 200 and 400 will give you a suitable rating. Second, if the resulting shutter speed is still slower than 1/2 second, then apply your camera's Noise Reduction function.

If noise is still prevalent in your picture after in-camera processing, then there are several noise-reduction software packages available. Dfine by Nik Software is popular with many professional photographers.

LEFT
This image is adequate, but lacks contrast, as the histogram beneath it illustrates. Checking this in-camera allows you to make adjustments.

BELOW LEFT
Setting ISO-E to 200 and a shutter speed of three seconds was complemented by the camera's NR function to produce a good image.

QUICK GUIDE TO USEFUL CUSTOM FUNCTIONS

Unless your subject is moving erratically, reduce the number of manually selectable focus targets to speed up AF operation.

In Continuous-servo AF mode, priority is usually given to the shutter and the shutter release is active whether or not the subject is in focus. Reset this custom function to Focus-priority. This will ensure you don't take out-of-focus pictures.

For more minute adjustments of exposure, set exposure steps to 1/3 EV rather than 1/2 EV steps.

Adjust the diameter of the circle used for center-weighted metering to suit the specific subject you are photographing.

Turn OFF the instant-playback function, and review images only when necessary.

If using the self-timer in place of a remote shutter release, then set the time duration to its shortest delay (usually two seconds).

Night photography and WB

The other consideration when photographing scenes at night is which WB setting to use. The correct setting will depend greatly on the subject and any light sources within the picture. While Auto WB will produce acceptable results most of the time, I have found that setting WB manually produces far better results.

For natural-looking pictures without the effect of color casts on scenes that are primarily lit by street lighting, I will set a WB of around 6000K (similar to the CLOUDY or TUNGSTEN preset WB setting on many DSLRs). When the primary light source is fluorescent, such as the lighting found in a sports stadium or used to light buildings at night, I use a WB of around 5000K.

Adding an image comment

Some DSLRs allow you to append a comment to an image via the menu screens. On journalist assignments I have found this to be a particularly useful tool, allowing me to record the location of a series of images and avoid having to make notes on scraps of paper. This function can also be used to help protect images from copyright theft, since a © symbol can be added to the shooting data as a permanent record.

ABOVE
The aim of night photography is to achieve a natural-looking image: a difficult task when artificial lighting can create a strong color cast in difficult lighting conditions. Setting the WB function manually is the best way of realizing your vision.

IMAGE-SHARPENING

Image-sharpening, particularly USM work (see page 160) in-computer, will increase the effects of digital noise. Avoid applying image sharpening to photographs that already show a high level of digital noise.

Case studies

The following case studies all identify some challenging conditions for the digital photographer and the camera techniques used to overcome them. While every scene you photograph will provide a different set of circumstances that require you to make the right choices when selecting camera settings, the studies here will help to visualize how to get the perfect balance between subject matter and technology.

CASE STUDY ONE: MONT SAINT-MICHEL

The challenge

This scene required a long time exposure, where digital noise would cause image-quality issues. Another challenge was the balance of ambient and artificial lighting that needed to be controlled effectively with the WB setting.

The solution

I set ISO-E to 200, giving a shutter speed of 3 seconds and a good balance between heat generation (shutter speed) and amplification (ISO-E rating). I then applied the NR (Noise Reduction) function via the menu options. WB was set to DAYLIGHT (SUNNY) and adjusted to 5,000K to give a natural color cast between the blue night sky and the artificial light on the building.

CASE STUDY TWO – THE LOIRE VALLEY

The challenge
One look at the sky in this scene and you can quickly distinguish that the overcast conditions are producing a very low level of contrast. Another, less obvious problem is the strong blue color cast caused by the weather conditions.

The solution
I shot a test image and carefully analyzed the resulting histogram, which showed a very narrow subject brightness range—seen in the image as a lack of contrast. The solution to this particular problem was to adjust the TONE compensation to add contrast. To overcome the strong blue color cast I set the WB to 7,800K (similar to the SHADE preset WB setting), which has added greatly to the warmth of the resulting image.

LEFT
This image had a strong, but not obvious, blue color cast and difficult light conditions. The solution was to adjust the TONE to increase contrast and set WB to 7,800K.

BELOW LEFT
This image has a strong, natural blue color cast that we want to retain. WB is set to 5,600K.

CASE STUDY THREE – ICE SKATERS

The challenge
The primary challenge with this image is the intense white of the ice under direct sunlight, which plays havoc with AE systems. Getting an accurate WB setting was also key to ensure an even balance between maintaining a natural color cast in the ice (which tends toward blue) and an aesthetically pleasing skin tone in the skater. Rather than a straight image, however, I also wanted to create a sense of motion and action.

The solution
To get an accurate exposure, I switched the metering mode to spot metering and metered from the face of the skater, adding 1 stop of exposure compensation (white skin is 1 stop brighter than middle-tone). I set WB to the DAYLIGHT (SUNNY) setting and adjusted it slightly to add a little warmth (5,600K). To create the motion blur, I then set a relatively slow shutter speed of 1/20 second and panned the camera gently to create just the right level of blur.

CASE STUDY FOUR – GRAY WOLF

The challenge

Apart from keeping my hands from freezing, the challenges with this image were numerous. First, the weather had significantly reduced levels of contrast and increased the cool blue color cast, both of which greatly detracted from the quality of the image. Second, I wanted to freeze the motion of the wolf but accentuate the falling snow, which meant clever use of shutter speed.

The solution

To increase the tonal range, I adjusted the TONE setting to add additional contrast. I then set WB to the SHADE setting to reduce the level of blue color cast. Although the weather conditions were closer to CLOUDY, the snow has exaggerated the blue tone, and the extra warmth that the SHADE setting produces hasn't overdone the effect, as it might have in less severe conditions.

I then had to select a shutter speed that would freeze the motion of the animal but allow the falling snow to streak. I settled on 1/80 and took the shot.

BELOW
Here another blue color cast was undesirable. I set WB to the SHADE setting to reduce this, rather than the more obvious CLOUDY setting.

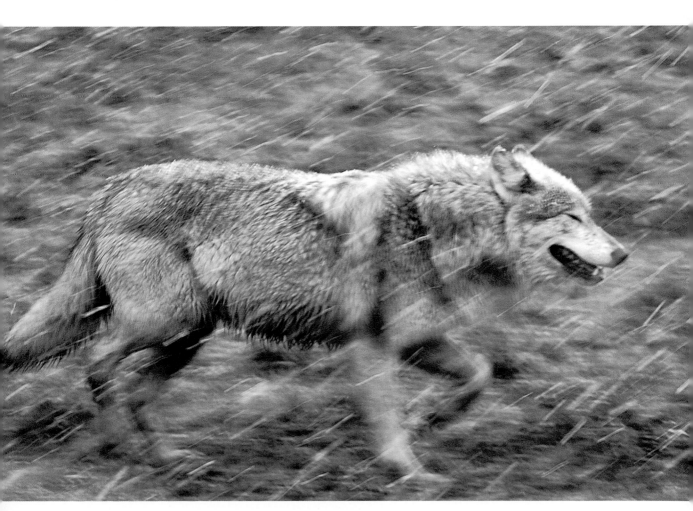

One of the distinct advantages of digital photography is the ability to set shooting parameters in-camera that were once only feasible in post-camera processing. There are two schools of thought when it comes to some of the advanced digital shooting techniques available with a DSLR. Some say it is better and easier to fine-tune the image in-computer using more powerful and sophisticated software than exists in-camera. Others say it speeds up workflow and increases time in the field if you manage image parameters in-camera.

In truth, it depends on the circumstances. If time is of the essence, which often applies to professional press photographers, for example, or if you have limited or restricted access to a computer, then it may be advantageous to manage the greater portion of image-quality settings in-camera. If time is less of an issue and you have easy access to the necessary image-processing software, then you may prefer to do your image editing in-computer.

Either way, what follows is a description of some of the options available in-camera and how to use them in relation to the prevailing shooting conditions.

SHOOTING MENU	
White balance	A
ISO	200
Image sharpening	+/-0
Tone compensation	0
Color mode	II
Hue adjustment	0
File compression	OFF
Image quality	RAW

RIGHT
Night shots with lots of bright artificial lighting like this can be a challenge for the photographer, so experiment with color spaces and see the results for yourself.

Color space

Most DSLRs have an option for setting the color space used by the DPS when recording an image. This setting is essential to accurate color management in the commercial world and also provides greater flexibility to photographers shooting for pleasure.

In terms of traditional photography, these settings are like changing your film stock. Essentially, you are altering the way the sensor records color, depending on the subject. Just as a landscape photographer with a film camera may choose to use Fuji Velvia film for added saturation, you can adjust the way the DPS handles color in the same way.

The color profiles used in digital photography form part of the ICC (International Color Convention) profiles that are an internationally recognized standard. In essence, once this color-profile data is saved along with an image, it can be reproduced on any device, anywhere in the world with accuracy. Two ICC profiles are used in DSLR cameras— sRGB and Adobe 1998.

LEFT
The effects of different color spaces can be seen here: top, sRG; bottom, Adobe 1998.

Adobe 1998

Adobe 1998 is the accepted standard for colorproofing images in the publishing industry. If you are considering having your pictures reproduced in books or magazines, then this is the profile setting you should use. The advantage of the Adobe 1998 profile is a far wider range of colors than sRGB, giving greater latitude during the printing process.

sRGB

The alternative is to set an sRGB color profile, and many DSLR cameras provide more than one sRGB option. Although sRGB has a smaller range of colors than Adobe 1998, often it produces better original images straight from the camera. So if you plan on using your images noncommercially, this may well be a preferred option.

Of the two common sRGB profiles available with most DSLRs, one is used for photographing people (sRGB 1) because it produces natural-looking skin tones, while the other is used for nature and landscape photography (sRGB 2) because it gives punchier, more saturated colors.

COLOR PROFILES FOR THE INTERNET

If you are photographing exclusively for publication on the Internet the images will obviously be viewed on an enormously wide selection of display types, some of which may not be of particularly high quality. To cover most of the bases, select the sRGB color profile.

SIMPLE COLOR PROFILING

Outside of commercial considerations, because the sensor in your DSLR, your computer monitor, and most default printer settings are all sRGB, you will find that setting sRGB on your digital camera will produce reasonable results in most circumstances.

BLACK AND WHITE (B&W)

Some DSLR cameras have a black-and-white setting, which records the image without applying color. I do not recommend using this option because once applied, it's irreversible. A better solution for making black-and-white images is to use tools available in Photoshop.

OPPOSITE
Color space can be altered to suit the subject. A natural color response is suited to portraits (opposite top), while nature photography will benefit from a vivid setting (opposite below).

RIGHT AND BELOW
Some cameras have a B&W setting that allows you to photograph B&W images in-camera, rather than the normal color version.

Image sharpening

By applying sharpening to an image, you are making the edges of objects more distinct (i.e., increasing the distinction between light and dark areas). This is another area of digital photography that is open to intense debate. Some recommend sharpening an image only in post-camera processing. Others will sharpen in-camera. So what's the best option for you?

The first point I would make is that all images that originate from a DSLR require some level of sharpening. Whether you manage this sharpening in-camera will depend on what you intend to do with the final image.

Direct printing

If you intend to print the image without any computer enhancement, then set the level of sharpening in-camera. How much sharpening you need to apply depends on the subject. From experience, I have found that photographs of wildlife, architecture, sports, and landscapes on a clear day benefit from a level of sharpening higher than the NORMAL setting in the camera. On the other hand, portraits of people and landscapes in hazy or misty conditions often look better with a lower level of sharpening that produces a "softer" appearance.

Nondirect printing

If you intend to edit the image in-computer before any printing takes place, then I would advise setting sharpening in-camera to NONE and managing the sharpening process either in the proprietary software that is supplied with your camera or in Photoshop, using the UNSHARP MASK or SMART SHARPEN filters.

BELOW AND BELOW OPPOSITE
These three images have all had different degrees of sharpening applied. Compare each one to see which you prefer. There is no right or wrong answer—though oversharpening soon becomes apparent.

SHOOTING MENU	
White balance	A
ISO	200
Image sharpening	+/-0
Tone compensation	0
Color mode	II
Hue adjustment	0
File compression	OFF
Image quality	RAW

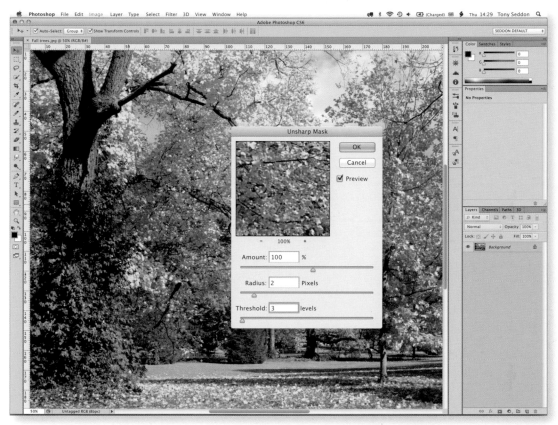

ABOVE
Image-sharpening can be applied either in-camera via the menu screen, or in computer software packages such as Adobe Photoshop, shown here.

SHARPENING AND INTERPOLATION

Because interpolation will exaggerate the sharpening process, it is better to apply sharpening at the very end of the image-enhancement process. For commercial purposes, most picture buyers insist on a non-sharpened image for this reason.

IMAGE SHARPENING IN-COMPUTER

Sharpening is one of the shooting parameters that can be adjusted in-computer using the proprietary software that is supplied by the manufacturer, without affecting overall image quality.

Tone (contrast) compensation

The tone setting is used to adjust the distribution of tones within an image to define the level of apparent contrast. Typically, I avoid using this setting in camera because it is often difficult to assess the appropriate level of contrast accurately using the LCD screen, and too much contrast can easily ruin an otherwise good picture.

If you decide to set tone in camera, then increasing tone will increase the level of contrast, making distinctions between dark and light areas of the image greater. Reducing the tone setting will lessen contrast, producing a "softer" result, and may be applied when photographing subjects in harsh, direct lighting.

Hue

Digital cameras produce color by adding two or more colors together. For example, taking the three colors used in digital image capture—red, green, and blue—mixing equal parts of red and blue will give you magenta. The same combination of blue and green will produce cyan, and green and red will produce yellow. An equal mix of all three will take you back to white. By adding various combinations of red, green, and blue light, all the colors of the visible spectrum can be created.

The hue-control function in a DSLR allows you to add an amount of color cast within a given range and in incremental stages. Red is the base color (0°); raising the level of hue above 0° will add a yellow cast to make colors that start off as red appear increasingly more orange (mix red and yellow and you get orange). Reducing the level of hue will add a blue cast, resulting in reds becoming purple. The greater the degree of change, the stronger the effect.

SHOOTING MENU	
White balance	A
ISO	200
Image sharpening	+/-0
Tone compensation	0
Color mode	II
Hue adjustment	0
File compression	OFF
Image quality	RAW

THIS PAGE
The TONE setting affects the level of apparent contrast between NORMAL (middle), REDUCED (left), and INCREASED (right).

OPPOSITE
By adjusting HUE, you can alter the base color. Here, the top image has been adjusted towards blue, the middle image is unadjusted, and the bottom image has been adjusted toward yellow.

SHOOTING MENU

White balance	A
ISO	200
Image sharpening	+/-0
Tone compensation	0
Color mode	II
Hue adjustment	0
File compression	OFF
Image quality	RAW

CUSTOM MENUS

Nearly all DSLR cameras have a series of menus that allow you to customize the way your camera records an image and handles in the field. Many of the options available are covered within the pages of this book under their appropriate heading. Customizable functions will vary from camera to camera, and I recommend referring to your camera's manual for more detailed information, using the advice found throughout these pages to assess how to customize your camera to suit your personal photographic style.

ADJUSTING HUE AND TONE IN-COMPUTER

Hue and tone are both shooting parameters that can be adjusted in-computer using the proprietary software that is supplied by the manufacturer, without affecting overall image quality.

3

IMAGE PROCESSING

THE DIGITAL DARKROOM

ABOVE
The use of Photoshop poses difficult questions: is the image above a perfectly taken shot? Or have some elements been enhanced, or even added in-computer?

BELOW
This is an example of in-camera motion blur, where the blur is of the subjects moving while the shutter was open. But you can imitate this effect in software too.

The focus of this book so far has been on achieving the best possible image quality in-camera. Just like film, however, digital photosensors have limitations, and there are times when a little external processing is required. The underlying workflow is no different in digital photography than in creating the final image from a negative or transparency. Once the raw data is captured and stored, whether it's in the form of pixels or chemically altered silver crystals, then additional processing can be applied in the darkroom or digital studio using skills and techniques that are common to both. The main difference between the two methods—for me at least— is that the digital workflow is far more convenient, quicker to master, and definitely less smelly than the traditional route.

The purpose of this section of the book is to answer a simple question, "How do I set up and operate an effective digital workflow?" Because that is the objective, I will avoid getting too embroiled in the minutiae of speeds and feeds, or the debates on the merits of Macs versus PCs, or different brands of camera. I shall concentrate on helping you decipher the vagaries of the digital workflow and focus on the essential point: creating images from your digital originals that are true to your creative vision.

I am not a computer expert or an Adobe Photoshop guru; I use both as a tool for the job in hand, and I use them only when strictly necessary. Therefore, the advice that follows is based on my experience as a working professional who uses this technology on a daily basis. I accept that others may have their own preferences and may wish to debate the system I use. Yet this is what works for me and other professionals that I know.

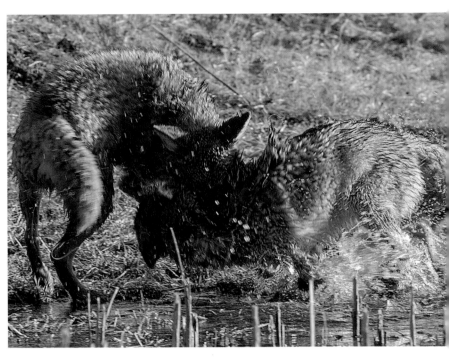

ABOVE
This image used a fast shutter speed to "grab" the moment and freeze it in time. But images such as this can be digitally composited from separate shots.

RIGHT
This image has been altered in Photoshop: not to alter the subject, or to "cheat", but simply to enhance the color balance— just as you would in the darkroom.

THE ETHICS OF COMPUTER MANIPULATION

In the context of photography, manipulation and enhancement are two different things. Practically every professional photographer enhances his or her images in some way, whether it is in-camera—applying filters or varying film stock, for instance—or in the darkroom using, for example, selective exposure, dodging and burning, or unsharp-masking techniques. Computer enhancement is merely a more convenient form of achieving something photographers have been doing since photography was invented.

Manipulation, on the other hand, is the falsification of an image for the photographer's own advantage. Whether it is right or wrong to do so depends entirely on the context. For example, a natural-history image that is used to illustrate animal behavior, or place the subject within its natural environment, should be a factual record of the events as seen. However, the same image used for commercial advertising can be altered to fit the message, so long as it refrains from being criminally misleading.

My personal view is that an image enhanced in such a way that it more closely portrays a scene as the photographer saw it is acceptable. However, it is unethical to pass off an image as something it is not.

I say this not simply in reference to ethics. As manipulation becomes the norm, our trust in the photographic image as a true account of history is diminished and, increasingly, the integrity of our profession is being lost. Now when we are confronted with an image that is too good to be true, we simply accept that it is false, a smorgasbord of made-up pixels, rather than the exquisite result of the far-reaching vision, effort, and sublime camera technique of a photographic master. This does nothing to further our profession.

Setting up a digital darkroom takes a considerable amount of forethought if expensive mistakes are to be avoided. With the speed at which technology changes, it is easy to invest in the wrong piece of equipment and just as easy to be fooled by marketing hype into buying something you don't really need. Different photographers will have their own opinions on what's hot and what's not. In the following section, my aim is to provide you with enough information so that you can at least make an informed decision.

There are four distinct stages to the digital workflow:

1. Getting the source image onto a computer
2. Processing the image using application software
3. Storing and managing the processed images
4. Outputting the image

There are also three considerations when designing a digital workflow:

1. Efficiency
2. Reliability
3. Speed

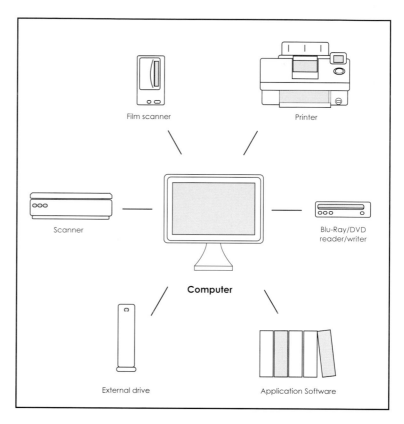

Film scanner

Printer

Scanner

Blu-Ray/DVD reader/writer

Computer

External drive

Application Software

RIGHT
Transferring the image onto your computer is just the first stage in its journey through the digital darkroom and your digital workflow.

ABOVE
This kind of setup is the heart of the "digital darkroom," whether you use a PC or a Mac.

CAMERA-TO-COMPUTER TRANSFERS

Transferring images from the memory device to the computer via the camera body tends to be a slower process than using a card reader. Also, I have sometimes encountered problems with the interface that, while not insurmountable, have often tested my patience.

DOWNLOADING FROM THE CAMERA

When you download images via the camera body, the computer automatically launches the proprietary software supplied by the manufacturer. Once the computer has recognized the camera, close the proprietary software and drag and drop the files into a folder.

BELOW

A card reader capable of reading mulitple formats will prove useful if you have more than one camera and are using different kinds of card.

BELOW RIGHT

You can slot your camera's memory card into a PC card adapter, enabling you to slot it directly into a laptop, for example, for editing.

Downloading images to a computer

The first stage in the post-camera process is to get the image data from the memory device into a computer. The two most important aspects of this stage of the workflow are reliability and speed.

In the studio, typically I download my images from the CompactFlash card via a card reader. I find this a more convenient and speedier option than transferring images via the camera body, which is the method I use when working in the field. (An alternative to the card reader is to use a PCMCIA card adapter. The disadvantage with this option is that the speed of these devices is up to three times slower than a USB 2.0 or FireWire device.)

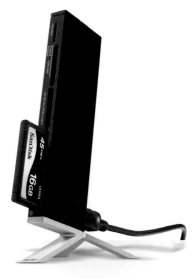

CARD-READING DEVICES

Some devices allow you to slot a memory card directly into it. In other cases, you can use a dedicated card reader—connected via USB, for example—an adaptor that slots your memory card into a PC card (for a laptop), or another device interface.

CONNECTIVITY STANDARDS

I've run some tests on USB 2.0 and FireWire and found download speeds to be almost identical—and about three times quicker than PCMCIA card adapters. FireWire connectors in Windows-based laptops tend not to be powered, meaning that you'll need a separate AC adapter to power the card reader. This does not apply to Mac-based laptops that have powered Firewire connectors. USB 2.0 connectors are powered in both types of machine so may be a preferable option if you use a Windows-based laptop. Any USB 1 devices you may still own are very outdated and should probably be replaced as soon as your budget allows.

Memory

When choosing a computer for digital photography, you should spend your money on memory (RAM). The importance of a high-capacity memory chip cannot be understated. For example, the file size of a typical digital picture originated in-camera is 15–30MB, depending on the model of camera. Once you start using multiple adjustment layers in Photoshop, the file can quickly double or triple in size. Add to this the running of the application software and the operating system, and you can see how RAM can quickly be swallowed up, at which point the computer begins to operate via the scratch disk. Not only will this slow down the whole process, once the scratch disk is full, your system will come to a grinding halt. Memory today is relatively cheap, so buy as much as you can afford. A minimum of 4GB is preferable if budget allows.

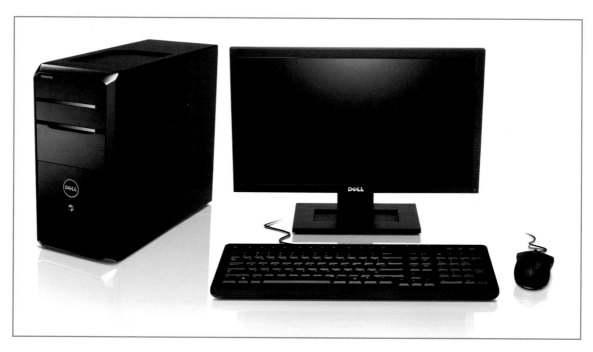

ABOVE
PCs are by far the most popular type of computer used today. Powerful multimedia setups can now be bought for relatively little cost. Image courtesy of Dell Inc.

RIGHT
For many photographers, a high-specification laptop is a better solution than a large, cumbersome home PC or Mac, as they are portable. Image courtesy of Dell Inc.

WHAT IS A SCRATCH DISK?

The scratch disk is temporary disk space on the hard-disk drive, which is used for storing data and performing computations. Photoshop uses a scratch-disk file when there is insufficient RAM for image editing, which can reduce processing speed in Photoshop.

COMPUTER MEMORY

If the machine you're considering has a small amount of pre-installed memory, consider getting a RAM upgrade to at least 4GB. The extra cost is worth the investment and will greatly speed up your digital workflow.

COMMON PHOTOSHOP ERRORS

When opening an image in Photoshop, the scratch-disk must have available disk space equal to between three to five times the file size of the image. (For example, if the file size is 20MB then the scratch-disk must have between 60–100MB of free space available). If the scratch disk is nearly full, then Photoshop returns the error message, "Scratch Disk is Full," or similar. For a complete list of solutions to this problem, please refer to the Adobe website (www.adobe.com).

Processing power

The processors in today's computers are so powerful that speed has become far less significant when choosing a machine. Even the slowest computers on the market are fast enough for all but the most demanding professional image-processing tasks. It is now also easier to compare the performance of both a PC and a Mac than it used to be, as both platforms use Intel processors rather than RISC chips in Macs and Pentium chips in PCs. This helps to take some of the guesswork out of choosing the right machine to purchase.

Hard-disk drive (HDD)

The other consideration when choosing a computer is the hard-disk drive (HDD). Hard-disk storage is inexpensive, and most machines now offer large capacity internal disk space. However, remember that digital files can be of considerable size, and 1GB of disk space will only hold around 41 25MB images. If your image library starts to grow, then it won't take long to fill an internal drive—once you've taken into account all the space used by your applications and operating system software.

ABOVE
HD space will soon run short when saving digital picture files. A large-capacity HDD is a prerequisite in the digital photographic studio, and many are portable.

RIGHT
New computer chips' processing power doubles every 18 months, which is why PCs are out of date almost as soon as you buy them. They key is simply to get one that works for you.

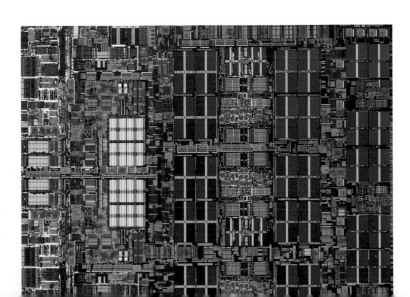

Computer monitors

Perhaps the most important feature of your digital darkroom is the monitor. The most important consideration is that you have independent control over the red (R), green (G), and blue (B) intensity, as well as the white-point settings. Without this level of control, it will be impossible to achieve successful color management throughout your digital workflow.

Historically, computer monitors came in two forms, the older CRT (cathode ray tube) box-like monitor, and the flat-screen LCD (liquid crystal display) screens. These days it's impossible to buy a CRT monitor (although their relevance to photography arguably remains high), leaving the smaller desktop footprint LCD monitor as the only practical choice.

The two main considerations when buying an LCD monitor are the brightness rating and contrast ratio. For photographers, a high brightness rating is more of a disadvantage because of the difference between a bright monitor image and a print. A low brightness setting of around 140-100 cd/m2 (80 nits) will help to produce more accurate colors in print.

Similarly, although there are screens with contrast ratios of 1000:1 and more, a ratio of 500:1 is adequate for photographic applications.

Another consideration is the size of the monitor. As flat screen monitors take up less desk space, it is more feasible to have a larger screen. Given the amount of real estate taken up by software panels, go for as large a monitor as you can afford.

Application software

There is a plethora of software on the market aimed at photographers covering RAW conversion, image processing, asset management,

DUAL MONITOR SETUPS

You will find you have a more efficient working area and a higher quality on-screen image if you work with two 17–19in monitors operating in tandem rather than a single 21in or larger monitor.

KEY CONSIDERATIONS

- Independent control over RGB color intensity
- Sharpness
- Screen type

ABOVE LEFT
A good-quality color monitor is important for accurate and successful image processing

BELOW LEFT
The iMac from Apple has repeatedly proven its worth as a professional workstation for photographers. It is certainly now a standard in many photography studios and art departments.

Image courtesy of Apple

MACS AND PCS

The Mac-versus-PC debate has historically shared the same intensity as the original arguments over digital versus film or Nikon versus Canon. I use a Mac for three main reasons. First, I have found Macs to be far more reliable than PCs. Second, the majority of the imaging industry, including publishers—one of my primary markets—tend to use them. Finally, I have always preferred the color-management tools available with Macs rather than with Windows-based computers.

Often the problem comes in comparing the two options. On the face of it, you get more for your money with a PC than you do with a Mac, but you can't simply compare the two machines on their specifications alone. Try to find the latest "benchmark test" results on any machine you are considering to see how certain tasks compare between platforms or models.

More often than not, what it really comes down to is personal taste and what you can afford.

resizing, noise management, filter effects, color management, and more. For a basic workflow you will need to consider a minimum of RAW conversion, image processing, and asset management, with many of the options likely to be available within a single core product. For example, Adobe Photoshop comes with a RAW converter package (Adobe Camera Raw), a sophisticated image browser for input of Metadata (Bridge), and with noise management, resizing, and filter effects built in.

ABOVE

Monitor calibration solutions, such as LaCie blue eye pro (shown here), are designed to help graphics professionals. Its simple calibration flow automatically adjusts the monitor in hardware to your target color settings.

TOP RIGHT

The dialog window of a monitor-calibration tool is something you should pay attention to. Having an incorrectly setup monitor means you have no way of accurately judging color until you print.

RIGHT

The technology behind flat-screen LCD (liquid crystal display) monitors creates sharp images.

EXPANSION

Buy a computer that allows you to expand on components, such as adding additional RAM or internal disc space. Also make sure the machine has enough FireWire or USB ports to support your peripherals. You can buy USB hubs that allow you to attach a number of USB devices via a single port on the computer base. Apple's new Thunderbolt technology is also worth a look.

HARDWARE CALIBRATION AND LCD MONITORS

If you have an LCD monitor, before choosing a hardware calibration solution, check that it is compatible with your monitor.

CALIBRATING YOUR MONITOR

You will need a monitor with independent control over the individual electron guns as well as the white point. Photoshop and Mac OS both provide built-in software-calibration tools but they are unsuitable for critical applications. Instead, use a hardware-based calibration system.

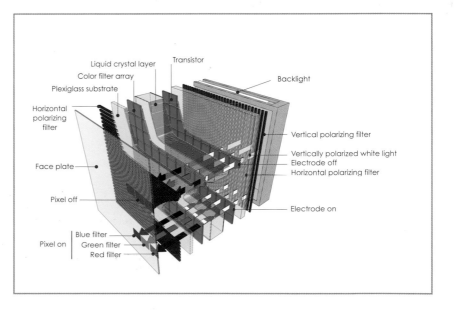

Photo processing

Adobe Photoshop is the industry standard when it comes to image-processing software, and a scaled down version aimed at consumers rather than professionals, Adobe Photoshop Elements, is also available. While many of the everyday Photoshop functions are available with both packages, with Elements you will find some limitations. Given that, Elements will handle pretty much all the basic correction tasks you will ever need for a standard workflow.

Photoshop is a complex package but worth getting to grips with if you're serious about digital photography. I cover some of the basic, commonly used applications of Photoshop later in this chapter, but to really get to know the software try one of the many dedicated books available or subscribe to an online tutorial service.

Interpolation

To reproduce digital images at a size and quality greater than their original resolution permits, you need to resize the image file and interpolate it (see page 159). Photoshop does a good job with most images but there are also some dedicated third-party software solutions available. I use a piece of software called Perfect Resize (previously known as Genuine Fractals) which is a dedicated interpolation application that runs within Photoshop as a plug-in and is used by many professional photographers. Perfect Resize uses complex algorithms to produce the interpolated file, which increases the quality of the final output. I have seen images interpolated from sub-10MB originals up to A0-size prints with little noticeable loss in quality.

COLOR MANAGEMENT

"Why does the image on my monitor look nothing like the one that comes out of my printer?" is a question that I've been asked many times. The answer is, because the two devices "manufacture" color in different ways. Your monitor makes color by adding varying amounts of red (R), green (G), and blue (B), while your printer creates color by subtracting different quantities of cyan (C), magenta (M), yellow (Y), and black (B).

The outcome is that RGB devices (monitors, digital cameras) can produce a wider range of colors than CMYK devices (printers), but CMYK devices produce additional hues. Either way, they are not identical.

Color-management systems have been designed to help overcome these problems by describing the color of pixels and changing the value of pixels to keep colors consistent across different devices. They do this using three components:

- A reference color space—representing color as we see it
- A device profile—that defines a device's color behavior
- A color engine—which matches color between conflicting devices.

The color reference space represents color in terms of human perception, which results in an unambiguous color model—unlike RGB and CMYK, both of which are variable. In essence, the color reference space becomes our base color model and is represented by CIE XYZ (1931) and CIE LAB (1976).

A device profile is built so that the computer can "understand" how each of the devices within the workflow handles color. Once this is a known quantity, the system can determine what actual (XYZ or LAB) values the RGB/CMYK values represent. This helps the system to instruct the color-reproducing device (printer, monitor) on what RGB or CMYK values it needs in order to reproduce the true color.

Finally, the color engine is the bit of software that actually changes the values in the files between devices in order to keep color consistent throughout the workflow.

Asset management

When I was deciding on an asset-management software solution, five things were important. First, it had to offer unlimited capacity, since my stock library contains several thousand images and is growing daily. Second, it had to have a powerful search engine so I could quickly and efficiently locate images. Next, I wanted the facility to create customer-specific folders that could easily be burned to CD or DVD. It also had to be able to read Nikon NEF RAW files (I use Nikon cameras and always shoot in RAW mode) and,

finally and ideally, have the ability to embed caption information and keywords for when I transfer the images to one of my agencies, to reduce duplication of work. I found all these functions within a package called Portfolio, by Extensis, and this is now my preferred software for asset management (see page 167).

ALTERNATIVE SOFTWARE PACKAGES

As well as those mentioned here, consider the following alternative software packages:

For photo processing
—Adbe Photoshop Lightroom
For interpolation
—Photozoom Pro
For asset management
—Expression Media Pro

LEFT
There are many software solutions for cataloging your digital images. An industry favorite is Extensis Portfolio.

The quality of the photographic image produced by modern printers, even low-cost printers, can be quite amazing. The difficulty tends to be in ensuring that the image on paper resembles the image on screen. This is partly due to the different color processes used. Computer monitors (and digital cameras) reproduce color by adding combinations of red, green, and blue (RGB). Printers, on the other hand, create color by subtracting combinations of cyan, magenta, and yellow (CMY), usually adding in black (represented by "K" for "keyplate") to reproduce a deeper black than can be formed by the three CMY primaries. Therefore, the color gamut of RGB differs to that of CMYK. This means that the colors you see on your computer monitor cannot all be reproduced accurately by the printer because the printer doesn't have the range of colors that the monitor has. Similarly, the printer can reproduce certain hues that cannot be created by the monitor.

There are two types of printer commonly used by photographers: low-cost ink-jet and more expensive dye-sublimation printers. Because of the different technologies used, as well as the wide choice of inks and papers, results can vary considerably, and one of the best ways to decide which printer suits your personal style is to reproduce the same image on many different machines and compare the results.

Resolution is a determining factor in the quality of the final image produced by the printer, although alone it is not the definitive factor. Printers work by positioning tiny dots

of ink across the paper (look at the pictures in a magazine through a loupe or magnifying glass to see the result). The number of dots determines resolution, which is referred to as dpi (dots per inch), and generally speaking, the greater the dpi, the better the quality will be.

However, quality also depends on the printer type. For example, a dye-sublimation printer with a resolution of 300dpi will produce better results than an ink-jet printer with a resolution of 1,400dpi. This is because each pixel on an ink-jet printer is a cluster of many ink drops, and the accuracy with which the cluster is formed will have a profound effect on perceived resolution. So for ink-jet printers, the

size of the ink drops (the smaller the better) is more important than the dpi.

The technology used by different printers will also affect the speed at which they reproduce the image on paper. You should also consider the cost of running a printer. Most manufacturers give a cost-per-page figure with their marketing literature, which provides a useful guide. Also bear in mind the number of ink cartridges used by the printer. Less costly printers have two cartridges, one for the three colors CMY and the other for black (K). More expensive printers have four, six, or seven cartridges, with one each for the CMY colors plus black; printers with seven cartridges also have cyan, magenta,

TOP LEFT
Most desktop ink-jet printers will create high-quality prints when used with good paper and inks.

ABOVE AND RIGHT
Whatever your favorite subject, be it animals, landscapes, people, or another aspect of photography, producing photo-quality prints from your digital files is what we are all striving for.

and gray. In the short term, it may seem more expensive to have to buy individual cartridges for each color but printers use up the different colors at varying rates. If you have a single color cartridge, then you'll need to replace it even if only one of the colors has run dry.

KEY CONSIDERATIONS: PRINTERS

Resolution
Speed
Running cost

RIGHT
When setting print parameters, it is vital to tell the printer what type of paper you are using.

BOTTOM RIGHT
You must also tell the printer the size of the paper you're printing to.

EVALUATING YOUR PRINTS

Ideally, you should examine your prints in the same lighting conditions under which they'll be displayed. If this isn't practical, then neutral lighting is best. At least be aware that the brightness and color of light will affect how the print looks to the naked eye. If the light is too bright, you will be unable to evaluate overall lightness or darkness accurately, although bright light is good for examining fine detail. In daylight, your prints will have a bluer color cast than when viewed under a household lightbulb, which will tend to create a warmer, orange color cast. The ideal light for viewing prints is a Deluxe Cool White tube. When checking for fine detail, use a loupe or magnifying glass.

PRINTER PAPER

The paper you choose will make a significant difference to the quality of the print from your printer. I have tested several papers over the years and have standardized on the papers made by Tetenal (www.tetenal.com) because they produce the most consistent results.

SETTING PRINT PARAMETERS

Before you send the image to the printer, check that you have set the print parameters to the appropriate settings. Paper type should be adjusted to suit the paper in the printer, and "Best" or "Highest Quality" should be chosen when making the final print. Set dpi to around 300.

SIMPLE IMAGE EDITING TECHNIQUES

Editing files

Once I have uploaded all of my images I cull them in an initial edit using Bridge. When I turn on my computer I have it configured to automatically launch both Photoshop and Bridge simultaneously. Alternatively, you can launch Bridge from its desktop icon, or directly from Photoshop by clicking the Bridge icon at the top left of the Application Bar, or from the File menu [File > Browse].

The Bridge workspace is made up of two main sections, with menu bars along the top and bottom. The workspace is divided into two sections, with the main viewing screen to the right and Favorites/Folders, and Metadata/Keywords palettes to the left. The size of each palette can be changed by clicking on the dividing bars and dragging with the mouse. Typically, during an initial edit, I hide the palettes to increase the area of the viewing workspace.

The Path Bar at the top of the screen indicates the location of the current folder or selected image by listing out the folder hierarchy. On the right-hand side you will find a number of filter options, workspace selections, a search field, and an option to switch to compact mode, which folds away practically all but the header bar, revealing the computer desktop below.

The bottom menu bar shows the number of items in the current folder, together with the number of items selected in that folder. To the left of the menu bar there is a slider that determines the size of the thumbnails (sliding to the left makes them smaller, to the right larger) and the viewing mode. There are four viewing modes: two thumbnail options, a detail view with listed metadata alongside each thumbnail, and a straightforward list.

For editing purposes I always use the Filmstrip workspace, which provides me with a row of thumbnails that I can quickly reference, as well as an image of sufficient size so that I can make my initial culling decisions.

My initial cull is based on some obvious criteria: is the subject in focus, the image well exposed, and the composition strong? If I want to delete an item from the HDD I simply click on the Trash icon.

Sorting, arranging, and rating files

Before I begin the actual culling process I arrange the files into some sort of order, which can easily be done in Bridge using one of two methods. The unsophisticated method is to simply drag and drop files within the workspace, however with a large number of files this can be unwieldy and inefficient.

A more effective way of arranging image files is to use the star rating system. I recently returned from an assignment where I had been shooting for three separate projects and with multiple cameras. Once the images had been uploaded I used the star rating system to tag each image to its respective project, using one star for project A, two stars for project B, and three stars for project C. I then used the View > Sort > By Rating options to arrange the images by project.

Adding a star rating in Bridge is simply a matter of using the Command key with the relevant number key, i.e. 1 for one star, 2 for two stars, and so on up to five stars. Alternatively, use the Command key with the full stop or comma keys to increase or decrease ratings respectively.

Bridge also has a labeling system that can be used in much the same way. The labeling option uses colored labels to identify groups of images. Labels are applied by using the Command key with the numbers keys between 6 and 9, or via the Label menu option. To show how this might work in practice, let's take another example. Say I'm sorting a batch of images into two separate groups—one for my main picture agency and one for my secondary agency. I can label all the images for the first group with a red label, and the others with a yellow label. I can then sort images [View > Sort] by label ready for shipping.

Renaming files

Once satisfied that you want to keep the remaining images you may decide to rename the camera-generated image title. I name my images with a suffix that determines whether it is a RAW or TIFF file, together with a five-digit number. The number of each new image is simply one higher than its predecessor. The RAW and TIFF files of the same image share the same number. For example, if the RAW file is named D03115 then the TIFF file is named P03115. I do this renaming via a Batch Rename process in Bridge.

Batch renaming is a relatively simple task. In Bridge, select the images to be included in the batch process first, then open the Batch Rename dialog box [Tools > Batch Rename]. Select a destination folder (I move

the images from their temporary pre-processed folder to their permanent destination folder on my HDD). You then need to tell Bridge how you want your images renamed. Click Rename and the job is done.

Any retrieval syswtem is only as good as the data it has to work with, so it's important that the metadata is accurate and comprehensive. Bridge has a good retrieval engine that operates via the Find command in the Edit menu [Edit > Find].

Accessing Find will open a dialog box from which you can select the source file(s) and the search criteria. Several options are available, including searching by Filename, Label, Rating, and importantly, Metadata. You can

also add filters such as "contains," "does not contain," "starts with," and "ends with."

Adjusting RAW files in ACR

On the right side of the ACR screen are the adjustment settings that you will use to make alterations to a RAW file before completing the conversion. There are ten tabs, each with their own settings. The principle settings used are found under the (default) Basic tab.

White Balance (WB)

The WB setting allows you to alter the WB recorded in-camera. There is a drop-down menu with auto and custom setting options, as well as the default As Shot option. The As Shot setting reverts to the setting applied in-camera. The Auto setting is

RIGHT
The ACR workspace with the Basic tab active on the right of the screen.

BELOW
One of the strengths of Bridge is batch renaming, which allows you to easily rename and organize your images.

Photoshop's best guess for the appropriate WB value (Auto in ACR is not the same as Auto-WB on the camera). The custom setting is automatically invoked when a slider is adjusted manually, and the settings you select are retained by the image.

There are also two sliders that can be used independently or in conjunction with the preset values. The Temperature slider sets the bias between yellow and blue. Moving the slider to the right will increase yellow (effectively warming the image as when using an 81-series optical filter in the field), and shifting the slider to the left will increase the level of blue (cooling the image as when using an 80-series optical filter in the field). To gauge the effect of the Temperature slider, make exaggerated adjustments before settling on the optimal setting.

The Tint slider controls the bias between magenta (slide to the right) and green (slide to the left). A possible application for this control is to manage color shifts between natural-looking skin tones (magenta) and the vivid natural colors of nature (green). Again, experiment with different settings before settling on a preference.

Exposure, Recovery, Fill Light, and Blacks

Together these controls cover similar ground to the Levels control in Photoshop, but with greater accuracy and control. Exposure and Recovery fix any under- or over-exposure problems, Fill Light reduces shadow intensity, and Blacks adds saturation in only the black areas rather than the overall color of an image. The histogram will change dynamically during the process (when Preview is checked) to show the effects of any adjustments.

Sliding the Exposure control to the right lightens the image, while sliding it to the left darkens it. Where possible, move the control to position the white point on the composite histogram close to the far right of the horizontal axis to avoid clipping.

Brightness and Contrast

This subheading is now slightly erroneous as the Brightness slider has finally been removed from the ACR workspace. The global nature of the adjustment always meant it was a less than satisfactory way of managing contrast, so the move has been well received. The Contrast slider remains, all be it in a different position in the order of available sliders.

Clarity, Vibrance, and Saturation

The Clarity slider increases local contrast, and provides a good way of adding depth to an image. The Vibrance slider effectively replaces the Saturation slider as it cleverly only increases the saturation of unsaturated colors, making the Saturation slider more or less redundant.

BELOW
In complex lighting conditions, you need to take greater care over exposure decisions. Here, underexposing shadow areas creates a dramatic silhouette.

Levels Adjustment

The main purpose of the levels adjustment tool is to enable the remapping of pixels so that they better fit the available tonal range (0–255). For example, to increase contrast to its fullest extent, adjust Levels so that the darkest tones are equal to black (value 0) and the lightest tones are equal to white (value 255). To adjust levels open the Levels dialog box [Image > Adjustments > Levels] from the menu bar, revealing the representative histogram. Directly below the histogram you will see the three input sliders controlling shadows (left side, black slider), highlights (right side, white slider) and mid-tones (middle, gray slider). To set the darkest pixels to black (value 0), click on the shadows slider and drag it to the point on the histogram indicating the current

darkest pixel value. To set the lightest pixels to white (value 255) click on the highlights slider and drag it to the point on the histogram indicating the current lightest pixel value. The mid-tones slider can be used to lighten (slide to the left) or darken (slide to the right) the overall image without affecting the shadows or highlights. What we are doing with Levels is telling Photoshop to change (remap) original pixel values to a new value in order to adjust the tonal range of an image.

SETTING THE WHITE POINT

When using Photoshop's white Eyedropper tool, avoid selecting reflected highlights, such as the reflections from water, metal, or glass, as they hold no detail and will produce an inaccurate white point.

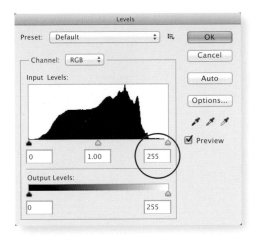

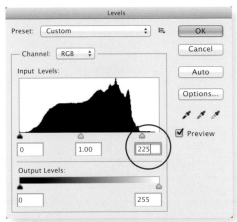

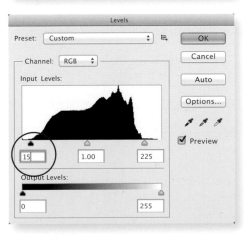

The Shadows/Highlights tool

When using the Shadows/Highlights tool [Image > Adjustments > Shadows/Highlights...], the detail visible in areas of shadow or highlight can be enriched independently. In particular, the Shadows/Highlights tool is an ideal means of revealing detail in images with a good tonal range, but where the extent of the tonal information is too tightly compressed to be fully visible.

The tool has two modes: basic and advanced. In basic mode, the amount of adjustment applied to both the shadows and highlights is set independently as a percentage. Increasing the shadows percentage above zero will lighten areas of shadow, enhancing shadow detail. Conversely, increasing the highlights percentage above zero will darken highlight areas.

Advanced Shadows/Highlights control settings

By checking the Show More Options box, the advanced Shadows/Highlights control settings are displayed. This adds Tonal Width and Radius to the shadows and highlights control options, and a new section called Adjustments for making color corrections, adjusting the mid-tone contrast, and setting the Black Clip and White Clip percentages.

It makes little sense to use the Shadows/Highlights tool and ignore these settings, so it is a good idea to keep them displayed. As with the Amount values, you can also change the default values for each of the advanced settings. I suggest setting a value of between 5 and 10 for all Shadow and Highlight values, then click the Set As Default button.

Tonal Width

Tonal Width refers to the range of pixels affected by the adjustment, starting from zero for shadow adjustments and 255 for highlight adjustments, and going through to middle-tone. For example, if the shadows tonal width value is set to 100 percent, then any adjustments made will affect all pixels from black to mid-tone gray. By setting Tonal Width to 50 percent, shadow adjustments will affect only those pixels that fall between black and half way towards middle tone. The same theory applies to the highlights. By adjusting tonal width you can define the range of pixels that are affected by Shadow/Highlight adjustments.

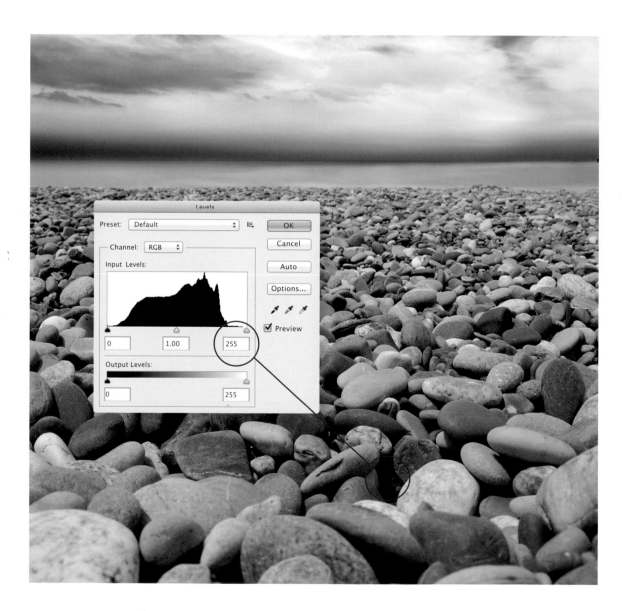

Radius

The Radius control setting determines the width in pixels of the area that Photoshop analyzes when calculating its corrections. As these corrections are based on data gathered from neighboring pixels, the wider the area the greater the number of pixels that are taken into account. This can be a good or a bad thing. If the radius is too narrow the adjustment will have little effect other than to produce a flat-looking image, as all pixel values between black, white, and middle tone become lighter (thereby reducing contrast).

Similarly, if the Radius value is set too high, more pixels are taken into account. This increases the likelihood that any adjustments affecting too wide a range of pixels will lighten the whole image and reduce contrast.

The optimum amount is somewhere between too few and too many, which is perhaps the least useful statement in this book. The difficulty is that it depends entirely on the image being enhanced, and the only way to determine the best value setting is by trial and error. As a starting point, however, set a value of around 10 pixels for Shadows and 20 pixels for Highlights.

ENLARGE THE IMAGE

With very finely detailed images, such as these pebbles, it is a good idea to zoom in on the image so that you can more accurately select your reference points for image remapping.

200% Untagged RGB (8bpc)

The Hue/Saturation tool
The Hue/Saturation dialog box contains three control sliders that manage hue, levels of saturation, and relative lightness respectively. Above these is a Master drop-down menu which allows you to work on individual color channels. Above that is a Preset drop-down menu where you may select options such as Increase Saturation and Sepia.

Below the lightness scale are three color eyedroppers used for making and fine-tuning color selections, and to their right, Preview and Colorize check boxes.

SATURATION LEVELS

It's easy to get carried away with the Saturation tool, but you should avoid overdoing things since images can become unnatural, with unrealistic colors unconducive to the subject.

At the bottom of the dialog box are two color bars, which provide a useful guide when performing adjustments. The upper box represents the input color values, or the color values as they appear in the original image. The lower box represents the output values, i.e. how the input values will be interpreted after adjustments have been made.

In its simplest form the Saturation setting increases or decreases overall saturation of the image colors, making them more vivid when saturation is added (slider pulled to the right), and increasingly less vivid when saturation is reduced (slider pulled to the left).

Pull the slider all the way to the far left and your color image will become grayscale.

This simple operation can be used to punch up the colors in an image in much the same way that film users might have chosen a very saturated film to reproduce vibrant colors. For example, nature photographers typically chose Fuji Velvia film for its vivid rendition of colors.

CLONING AREAS WITH FINE DETAIL

Cloning areas of single tone is relatively simple, but using the Clone tool effectively on areas of the image that contain large areas of detail can be more complicated. To make the job easier, enlarge the image until you can distinguish individual pixels and Clone one pixel at a time. This can be a lengthy process—one reason I prefer to keep my sensor free from dirt and dust with regular cleaning.

Cropping for alternative composition

You can change the story your pictures tell by altering composition using the Crop tool. Cropping can also be used to remove distracting background and foreground features or to simply "tighten up" the image space.

To crop an image, select the Crop tool and drag the automatically placed points inward to define the area of the picture you want to keep. You can also define the crop area by creating a new selection within the existing area of your image. When you've finished, you'll notice the area outside the crop grid darken.

Once you've selected the main area to crop around, adjust the parameters of the crop to the precise size using the top, bottom, and side points. When you're happy with the new composition, action the crop by selecting Image > Crop from the toolbar, or by clicking the tick checkbox to the right of the toolbar.

Resizing and interpolation

To achieve quality prints above a certain size, you may need to resize the original digital file—that is, "increase" the resolution, or number of pixels. In fact, you cannot increase resolution, but you can fake it to a degree before you compromise image quality, which will result in blurry images. The reason for the degradation is that bitmapped, or "raster," image types (e.g., JPEG, TIFF) are limited by their pixel resolution. When you attempt to resize the image, you are either increasing the size of each pixel (resulting in a jagged, or pixelated, image) or the software has to "guess" the value of additional pixels that it adds in.

There are two methods of increasing the size of an image: resizing and resampling. Resizing an image will increase the print size without altering the total pixel dimensions. This results in no actual loss in quality but print resolution (dpi) is compromised. An alternative method is to resample, or "interpolate" the data using computer algorithms. This process involves increasing the number of pixels in the image by adding new ones based on the value of existing pixels. Using this method, print resolution can be maintained, but image quality can be compromised because the computer is effectively "guessing" the value of the new pixels.

Most packages provide different interpolation methods. The most common are bicubic, bilinear, and nearest neighbor. Bicubic is the slowest of the three processes but produces the best results. Bilinear is quicker but less effective. Nearest neighbor takes the value of the adjacent pixel and mirrors it; this is a method best avoided because the results are often very poor.

JUDGING RESIZED IMAGE QUALITY

Unless you intend to display your images on a computer monitor alone, always judge the effects of resizing by looking at a print.

INCREMENTAL RESIZING

You may have heard advice that you can get a higher-quality result when resizing in incremental steps rather than in one single step. In my opinion the advice is misleading. Incremental resizing in up to ten steps does not always produce a discernible difference. If you resize in more than ten steps, image quality could be lost, and the problem will worsen as the number of steps increases. My advice is to stick to resizing in a single step.

Image Size

Pixel Dimensions: 36.6M (was 23.4M)

Width: 2920 Pixels

Height: 4380 Pixels

OK

Cancel

Auto...

Document Size:

Width: 247.23 Millimeters

Height: 370.84 Millimeters

Resolution: 300 Pixel / Inch

☑ Scale Styles

☑ Constrain Proportions

☑ Resample Image:

Bicubic Automatic

Nearest Neighbor (preserve hard edges)
Bilinear
Bicubic (best for smooth gradients)
Bicubic Smoother (best for enlargement)
Bicubic Sharper (best for reduction)
✓ Bicubic Automatic

Sharpening

Photoshop provides a number of options in the Filters > Sharpen menu. For basic sharpening I recommend using the Unsharp Mask option, which involves setting three values:

1. Amount

As its name suggests, the Amount control determines how much sharpening is applied (up to 500 percent). With the Preview box checked you can see the result of varying Amount, both in the USM dialog box (which shows a magnified section of the image) and in the

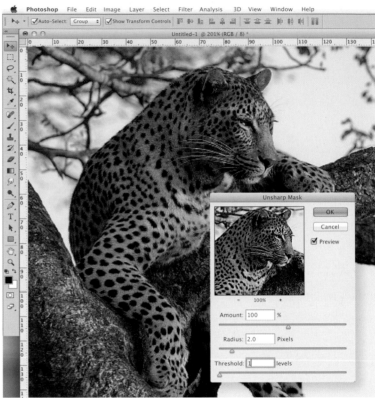

main image. For experience it is worth opening a test image and changing the amount value to see the effects. After a while you will get a feel for how much is too much. Typically, a value of between 50–100 percent (combined with a minimal radius and low threshold) is sufficient for replicating capture sharpening. You may want to increase the figure to between 125–200 percent for output sharpening.

2. Radius

Together with the Threshold setting, the Radius setting controls the extent of the sharpening effect. Individually, the Radius control defines the number of pixels from the edge pixel, to which sharpening is applied. Increasing the Radius value enhances the emphasis around edges but also increases the likelihood of introducing damaging

artifacts. Be wary of setting too wide a radius. Typically, a setting of between 0.5–1 pixels is sufficient, increasing to between 1.5–2 pixels for output sharpening.

APPLYING UNSHARP MASK

In image-processing, Unsharp Mask should be applied after all other image enhancements have been made and before any resizing takes place. Otherwise, image-quality may be compromised.

3. Threshold

While the Radius setting controls the number of pixels affected by the sharpen filter, the Threshold setting controls which pixels are affected. The Threshold control uses pixel brightness values to determine which pixels are sharpened and which are left alone. A low threshold value means that more of the image pixels are sharpened, while a higher value reduces the number of pixels affected.

For example, a Threshold setting of three levels means that any pixel more than three tones brighter than its neighbor will be sharpened. This is ok for mimicking capture sharpening,

but is less effective for improving edge sharpness and may have a detrimental affect on areas of continuous tone, such as clear blue skies, by introducing sharpening and its associated artifacts to areas that gain no benefit from the enhancement.

A high threshold value reduces the number of pixels to which the sharpen filter is applied and avoids areas of continuous tone from being affected, making a high value threshold more suited to edge sharpening. For example, setting a threshold value of 10 levels will cause only those pixels that differ to their neighbor in brightness by

10 or more tones to be affected. By definition, therefore, areas of continuous tone will be unchanged but clearly defined edges will benefit from the sharpening process. Setting a threshold value of zero determines that all image pixels are sharpened.

BELOW
To produce a "sharper" image from this slightly unsharp original, use the Unsharp Mask option under the Sharpen menu. This is based on pre-digital darkroom technique.

UNSHARP MASK AND COMMERCIAL SALES

If you are selling your work commercially rather than producing work for your own pleasure, avoid applying any sharpening to your images. It is better to leave that to the clients who buy your material as they will have their own idea of how much sharpening to apply before use.

LEFT AND BELOW
Unsharp Mask produces this "sharper" image (below) by creating a copy of the original, blurring it (left), and then comparing the value of the pixels in both. (The blurring stage is not visible to the user.) From this data Photoshop deduces edges and then heightens the contrast along those edges.

Saving files in Photoshop

Once you've completed processing the image, you'll need to save it. There are three main parameters that should be considered: file type, bit depth, and color space.

1. File type

The two main file types used in digital photography are TIFF and JPEG. (You may also come across GIF or PNG files, particularly on the Internet.) One of the principal differences between the two types is in compression technology. TIFF files use lossless compression, which means that although the file size is reduced, no data is discarded. When you come to open the full file, all the original data exists and image quality is not compromised. TIFF files are the standard file type used in reproduction.

JPEG files are compressed using lossy compression. When the software compresses the file, it discards some of the original data. The greater the compression, the more data is discarded. When the file is opened, the algorithms in the software then "guess" the value of the discarded pixels, and "made up" data is added to recreate the file. This obviously causes a loss in image quality—to what degree depends on the amount of compression. For example, a low level of compression (sometimes referred to as a Fine JPEG) will result in a high-quality image with little discernible difference from a TIFF file. A high level of compression (often called a Basic JPEG) is probably only suitable for reproduction online.

IMAGE PROCESSING IN 8 BIT

There are some Photoshop functions that can only be carried out on an 8-bit file; the particular functions vary depending on the version of Photoshop your computer is running.

COMMERCIAL PRINTING

For commercial printing, most reproduction houses prefer to do the RGB to CMYK conversion themselves, so they can match exactly the configuration of their own machines.

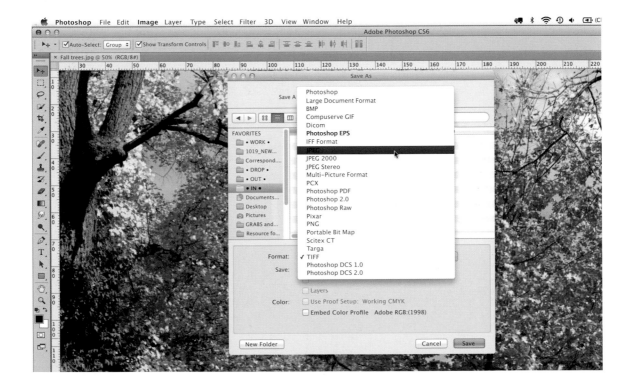

2. Bit depth

In Photoshop, an image can be saved as an 8-bit TIFF or JPEG file, or as a 16-bit or 32-bit TIFF file. For most applications, an 8-bit file is more than adequate; however, a 16-bit file increases the amount of information contained within each pixel. In the final print, you will notice little difference, but when processing an image in Photoshop you will have more information to play with. I do all image processing at 16-bit and save the final image as an 8-bit file.

3. Color space

Finally, you can save the image as an RGB or CMYK file. The option you choose depends on the final application. If the image is to be viewed on a computer screen, then opt for RGB (monitors reproduce colors using RGB). If you are sending the image to print, then CMYK will match the color space used by the printer.

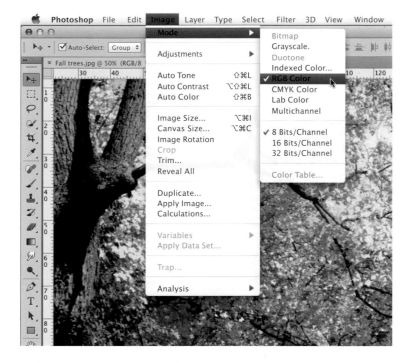

IMAGE PROCESSING IN 16-BIT

If you can work in 16-bit you will increase the amount of information available in each pixel. To the eye, the difference might be marginal, but it is best to work with the most data you can.

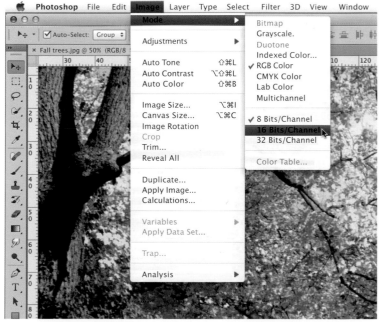

TOP RIGHT
RGB is the colorspace used by computer monitors, and therefore files saved for viewing on the Internet. CMYK is used in print reproduction.

RIGHT
Photoshop gives you the option to save the image finally to bit depths of either 8 or 16. It is best to work at 16-bit and then reduce if you need to.

The last stage of digital workflow

The final part of the digital workflow jigsaw is the storage and backup of images. As well as permanent storage, you should also consider how you are going to retrieve images later on your HDD. This is less of an issue when you have only a few images, but once the numbers start to increase, you'll soon forget which folder you've saved them in and a more professional approach will make life far easier.

Cataloging

The first step is to catalog each new file with your choice of asset management software. I give each image a sequential reference number and then drag and drop it into Media Pro from Phase One, my own preferred software solution. I add a description of the subject and append keywords to help with retrieval later on. The great beauty of asset management software is that it is location independent. Once you've added the file to a catalog, the software will be able to locate it, irrespective of whether you've stored it on an internal HDD, an external HDD, or a DVD.

Once the images are cataloged, I can simply search on the reference number (if I know it), a keyword, or a description to locate images to satisfy a customer request. From the search results, I can build new catalogs, which can be saved and sent to clients.

ABOVE RIGHT
Cataloging your images by embedding metadata is a simple discipline to learn, and one that will pay dividends in the long run.

RIGHT
Phase One Media Pro allows you to instantly view, sort, and manage your images. Pictures can be organized using visual catalogs and embedded metadata.

Alternative cataloging software

Many professional photographers use specialist software such as Phase One Media Pro or Extensis Portfolio for image cataloging, but there are several alternative and compelling software solutions on the market. It would be impossible to comment on all of them within this book, but here are a couple that you might want to take a look at.

Adobe Lightroom

Adobe Lightroom is a kind of one-stop-shop for photographers as it combines powerful cataloging functionality with adjustment features familiar from the Adobe Camera RAW plug-in. Add to that a built-in publishing manager, a sophisticated print facility, and the ability to create online galleries using

dozens of stylish templates and you may wonder why you would need any additional image editing software. It is important to point out that Lightroom is designed to work alongside Photoshop rather than to duplicate its functionality, and anyone that shoots and processes a high number of images would do well to consider running both as part of a larger image workflow.

A well designed context-aware panel features a Module Picker in the top right hand corner, which allows easy switching between cataloging, processing, and printing, in a manner akin to the sequential workflow observed by the average photographer. Panels to the left of the main viewing window handle the

browsing side of things, while panels to the right contain the tools needed to accomplish tasks such as color and exposure correction, and keywording to ensure metadata is kept up to date. Publishing to your Facebook or Flickr pages is also made easy through the provision of a dedicated Publishing Manager which stores export locations and file settings.

BELOW AND OPPOSITE
Lightroom provides a complete and logical workflow solution for photographers from catalog creation to image processing and publishing.

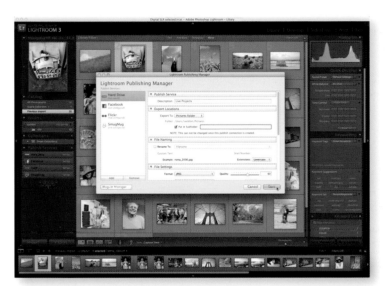

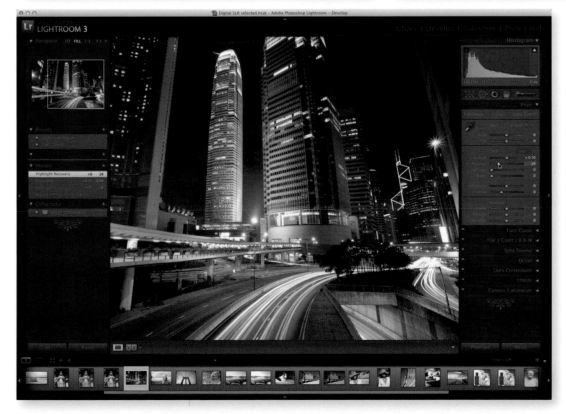

Apple Aperture

Although a dedicated Apple Mac program, Aperture is a versatile software solution that not only provides RAW conversion functionality, but that is also an excellent storage and retrieval facility. I am aware of many professional photographers who use Aperture in their daily work, including Jim Richardson who, for a recent National Geographic assignment, used the software to import, rate, and keyword 43,000 images. Using Smart Albums, a function of Aperture,

he effortlessly collected photos for different aspects of his story and made final selects using Light Table, an excellent sorting and arranging tool that works like a traditional light table.

In this way, Richardson uses Aperture in much the same way that I use a combination of Adobe Camera Raw and Extensis Portfolio for editing, selecting, storing, and retrieving large collections of images. The fact that Aperture manages this within a single

program may perhaps give it an edge, however the reason I stick to my current method is simply familiarity with the process. In the end, most of the storage and retrieval solutions offer much the same functionalities. As a user, it is down to you to decide which you find the most simple to work with.

BELOW
Aperture Smart Albums enables collections of images to be made simply and effortlessly.

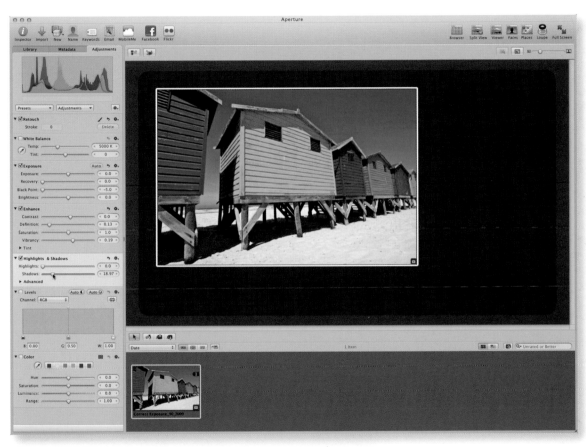

LEFT
Aperture also
enables the easy
compilation of photo
books; a useful
function for wedding
photographers.

ABOVE
Final edits can be
applied using the
full range of buit in
adjustment options.

File storage

I store all my files on external hard-disk drives (HDDs). First, I consider it a safe option. If my workstation fails for any reason or I decide to upgrade, I can simply unplug the external drive and plug it into a new machine. It's a far simpler process than copying files from one internal HDD to another. Second, it helps me keep my images separate from my application software, giving me more disk space.

BUYING AN EXTERNAL HDD

When you choose an external HDD, look for a model that has a FireWire or USB 3.0 connection, or one that supports Apple's new Thunderbolt technology. This will greatly speed up the transfer of data between the drive and the computer.

RIGHT AND BELOW
External HDDs, especially portable examples (top) are essential tools for the traveling professional, enabling the low-cost archiving of massive amounts of data.

HDD FAILURE—ALL IS NOT LOST

The HDD is the most likely component of a computer to fail. This is because it is a mechanical device with moving parts. You can help prevent disk failure by not moving it around and by "disconnecting" it from the workstation in the specified manner (refer to the HDD or computer instruction manual).

If your HDD does fail, there are Disk Recovery specialists who can often retrieve all the data stored on the failed disk. A quick search on Google will bring up a list of options. PC Inspector (www.pcinspector.de) is one such package, and many have found it to be successful.

**RAID—the ultimate in
storage redundancy**

For the serious photographer,
HDDs can be configured in a RAID
(Redundant Array of Inexpensive
Disks). RAID solutions vary from simple
disk mirroring to separation of data
over multiple disks. If one disk in the
array fails, then the original data
can be retrieved from the remaining
disk(s). For example, in a RAID 5
solution you have a minimum of three
HDDs linked via a RAID controller.

When the computer stores
information—for example, the number
67—figuratively speaking it writes the
first number (6) to disk 1, the second
number (7) to disk 2, and stores the
sum of the numbers (6+7=13) on disk
3 as a validation number. If disk 1 were
to fail and was replaced by a new
blank HDD, the computer can easily
calculate the missing bit of data by
subtracting 7 (from the second disk

in the array) from 13 (the verification
number on disk 3). The result (6) is
restored to the new, replacement disk,
and therefore no data has been lost.

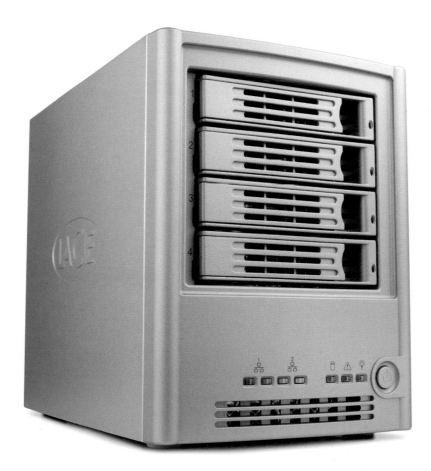

RIGHT
RAID solutions
are designed for
professionals who
require an easy,
affordable, user-
controlled backup
storage system.

ABOVE
USB flash drives offer
potential advantages
over other portable
storage devices—
they are compact,
portable, fast, and
have a durable design.

LEFT
Soon images like
this will be a thing
of the past, as new
DVD formats emerge
that can hold more
data than current
DVDs, and far more
than CDs.

Simple backup

RAID arrays are becoming increasingly affordable and are an ideal solution for a main backup. However, it's also worth having a remote backup to your main disk, which can be done by copying the data from the HDD to a DVD or, preferably, a Blu-Ray disc. CDs are largely impractical for backup purposes due to their low capacity.

Blu-Ray discs currently come in four flavors and can hold up to 128GB of data, meaning that only 4 quadruple layer discs are needed to back up an entire 500GB external HDD. You would need 10 of the regular 50GB discs but that is still not a lot. Over 125 DVDs are needed to achieve the same result. As the cost of Blue-Ray disc writers decreases, this is my recommended option for a simple backup solution.

USB flash drives also offer potential advantages over other portable storage devices. They are removable and rewritable storage capacities that typically range from 64MB to 32GB, with steady improvements in size and price per gigabyte.

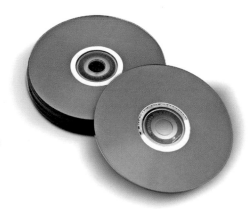

ABOVE AND RIGHT
Blu-Ray technology allows you to archive large amounts of data, and one disc can easily back up as much as 10 DVDs.

FILE BACKUP

DEVICE	ADVANTAGES	DISADVANTAGES	RECOMMENDATION
Workstation HDD	Already exists in your computer. Simple to adopt. Large capacity means you can store numerous files.	Also holds other data, such as application programs, which can limit capacity. Fixed, non-portable. If your PC fails, data can be difficult to recover.	Use when you first begin taking digital pictures.
External HHD	Portable from your computer and can be interchanged between machines. Can have very large capacities (200+ MB) giving you plenty of storage space. Can be dedicated to image storage, making them safer and giving even greater capacity. Plug-and-Play functionality make them easy to fit. USB 2.0 and FireWire connections are as fast as internal drives.	Additional cost. USB 1 devices are very slow to read and record data. Takes up extra space on the desktop.	Use when you are becoming more serious about your photography and are building up a large collection of valuable files.
CD	Cheap. Easy to implement. Relatively safe storage medium.	Limited capacity. Several discs can take up a lot of room in the home. Difficult to catalog effectively. Repeated use will degrade the disc.	Not recommended for backup.
DVD+R, +RW, -R	Relatively inexpensive. Easy to use. Larger storage capacity than CDs. Relatively safe storage medium.	Very large numbers of images will still require several DVDs. Effective cataloging can be difficult to achieve. Repeated use will degrade the disc. More expensive than buying the same capacity on a HDD.	Use for backup of small photo collections.
DVD-RAM	Relatively inexpensive. Easy to use. Larger storage capacity than CD's Relatively safe storage medium.	Only compatible with some devices. Very large numbers of images will still require several cartridges. Effective cataloging can be difficult to achieve.	Use as an alternative to DVDs.
Tape	Usually comes as a dedicated back up solution. Large capacity.	Complicated to implement without some understanding of computer technology. Expensive.	Use for serious commercial backup requirements.
HDD with RAID	All the benefits of internal or external HDD. Avoids the need for additional backup. Very secure. Large capacity.	Expensive. Requires some complicated IT components.	Use when your income relies on your picture files.
Online backup solutions	Unlimited capacity. Keeps backed up files offsite. Dedicated backup center that will offer its own redundancy protection.	Very expensive compared to other solutions covered here. Arguably requires a Broadband or better Internet connection.	For the paranoid professional photographer.
Blu-Ray disc (BD)	High capacity (up to 50GB).	Very few, although extremely large image libraries will still require multiple discs. However, this is unlikely to apply to the vast majority of photographers.	Recommended media for simple backup and additional backup to a RAID system.

UNDERSTANDING DVD FORMATS

When you buy a pack of DVDs you will notice that there are many different varieties available and deciding which is the right type can be confusing. What follows is a brief explanation of the formats currently available.

DVD+R and DVD+RW

Once data is recorded to a DVD+R disc it becomes permanent and cannot be erased. As such, DVD+R discs can be recorded to only once. DVD+RW discs, on the other hand, can be erased ot data and recorded to several times, making them more versatile (and more expensive).

Philips, Sony, HP, Dell and other manufacturers support +R and +RW formats. DVDs created by a +R or +RW device can be read by most commercial DVD-ROM machines.

DVD-R, DVD-RW, and DVD-RAM DVD-R and DVD-RW discs have the same recording properties as DVD+R and DVD+RW discs. They can be read by most commercial DVD-ROM players and are supported by Panasonic, Toshiba, Apple Computer, Hitachi, NEC, Pioneer, Samsung and Sharp, as well as the DVD Forum— an international association of hardware manufacturers, software firms, content providers and other users of DVDs.

Typically housed in cartridges, DVD-RAM discs can be erased and recorded to several times, similar to a DVD RW disc, but are only compatible with devices manufactured by the companies that support the DVD-RAM format.

Online backup

There are several companies now offering data back up online. This solution involves downloading files to an independent, external service provider over the Internet. They then store the data on dedicated servers for retrieval at a later time, if needed.

Many commercial organizations take advantage of this solution. Although it is overkill for most enthusiast photographers, anyone who is interested in making a living from photography, or has very valuable and large image libraries may want to take advantage of the benefits of this type of solution.

The downside tends to be cost: these services don't come cheap. Each service provider offers different solutions and fee structures, and you will need to research which are best for your own requirements.

A quick search for "digital photography backup solutions" in Google will yield a number of providers to look at.

STORING BACKUP FILES

Avoid keeping your backup files in the same location as your primary files. Give the discs to a friend or family member who can keep them safely in a different building, or, at least, store them in a different part of your own home or office in a fireproof safe. Alternatively, you could hire a safety deposit box at a bank.

PRESERVING HDDS

An HDD is the most likely computer component to fail. This is because it is a mechanical device with moving parts. As such, avoid moving an HDD unless absolutely necessary.

Avoid stacking HDDs on top of each other, even if they are designed for stacking. HDDs can get very hot and are best if air is allowed to flow freely around them to keep them cool.

When disconnecting an external HDD, always use the maker's recommended removal process. In Windows, this usually means using the Safely Remove Hardware option from the task bar. With Apple Macs, drag and drop the icon into the Trash.

When connecting an external HDD, make sure the cables are connected before powering on.

Only switch on an external HDD if you are going to use it. This will lengthen the life of the drive.

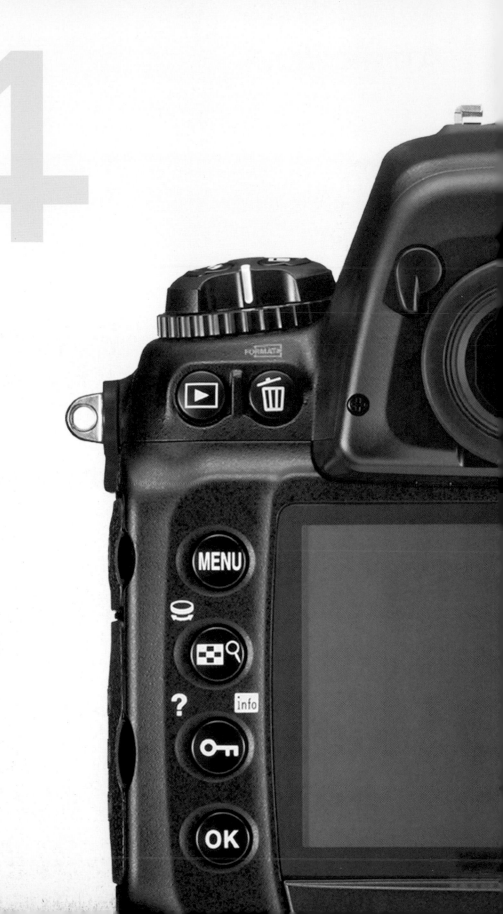

APPENDIX

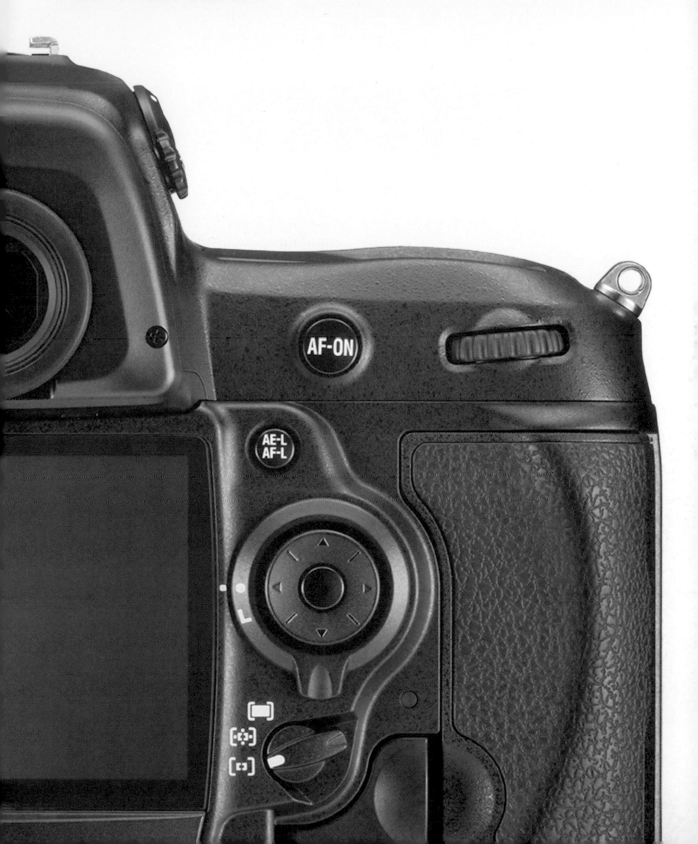

USEFUL LINKS

ADOBE.COM
Global website for Adobe

APPLE.COM
Official website of Apple computer

BYTHOM.COM
Extensive information on Nikon
equipment by Thom Hogan

CANON.COM
Global website for Canon

CHRISWESTON.UK.COM
Author's own website

COKIN.CO.UK
Official website of Cokin
(filter manufacturer)

DPREVIEW.COM
News, reviews, and digital
photography resource website

EPHOTOZINE.COM
News, reviews, and digital
photography resource website

EXTENSIS.COM
Official website of Extensis
(software provider)

FOUR-THIRDS.ORG
Official website for the Four-Thirds
digital photography standard

FUJIFILM.COM
Global website for Fuji

IMAGING-RESOURCE.COM
Detailed reviews of all the leading
digital cameras

INTRO2020.COM
Digital photography equipment,
including lenses, portable HDD,
digital media, and cases

KODAK.COM
Global website for Kodak

KONICAMINOLTA.COM
Global website for Konica Minolta

LEXAR.COM
Digital photography media

LIZARDTECH.COM
Official website of LizardTech, Inc.

MEGAPIXEL.NET
Digital camera web magazine

NIKSOFTWARE.COM
Computer software for the
digital darkroom

NIKON.COM
Global website for Nikon

OLYMPUS.COM
Global website for Olympus

PCTECHGUIDE.COM
Technical information covering
all aspects of PCs

PENTAX.COM
Global website for Pentax

PHASEONE.COM
Official website of Phase One
(software provider)

ROBGALBRAITH.COM
News, reviews, and digital
photography resource website

SANDISK.COM
Digital photography media

SIGMA-IMAGING-UK.COM
Official website of Sigma Imaging

TAMRAC.COM
Official website of Tamrac
(carrying systems for photographers)

TAMRON.COM
Global website for Tamron
(lens manufacturer)

VELBON.COM
Global website for Velbon
(tripod manufacturer)

WYOFOTO.COM
Technical information on aspects
of digital photography

GLOSSARY

APERTURE
A variable opening inside a camera lens that lets light pass onto the CCD sensor. Aperture settings are arranged in an internationally recognized scale measured in f-numbers. These are typically arranged as follows: f/2.8, f/4, f/5.6, f/8, f/11, f/16, and f/22. Wider apertures such as f/2.8 let in the maximum amount of light compared to narrow apertures such as f/22, which let in the least amount.

APERTURE PRIORITY (AP)
This is the most popular autoexposure option found in SLRs. Aperture priority works when the photographer defines the aperture value and the camera sets the right shutter speed to make a correct exposure. Aperture priority is useful when you want to create a particular depth of field effect.

ARTIFACTS
Unfortunate by-products of digital image-processing that degrade image quality, visible as small marks, or pixels of incorrect value.

AUTOEXPOSURE (AE)
When the camera automatically sets shutter speed and aperture value, so precise control over depth of field and movement cannot be guaranteed.

AUTOFOCUS (AF)
With this system, most compact cameras lock focus on the object in the center of your frame, which can cause a problem if your composition is off-center. Better SLRs have multi-zone autofocus systems, which can respond to more creative framing. Autofocus works best when locked onto an area with sufficient contrast.

AUTO WB
Automatic White Balance. See White Balance (WB).

BIT DEPTH
Describes the size of color palette used to create a digital image. 8 bit and 24-bit are common palette sizes, creating 256 and 16.7 million colors, respectively. This is because there are 256 different combinations of ones and zeroes in a digital word that is eight characters long—e.g., 10111011—and 16.7 million permutations in a digital word that is 24 characters long. See Digital.

BITMAP IMAGE
A bitmap is a common term for a pixel-based image. Also called a raster image, this describes a grid of pixels arranged in a checkerboard-like arrangement.

BLU-RAY (DISC)
Sony-backed recordable DVD format that uses blue lasers, rather than the standard red lasers, to record data onto specially formatted discs. Blue light has a much shorter wavelength than red light, so Blu-Ray discs have larger storage capacities than standard DVDs.

BLURRING
Blurred images are frequently caused by unsteady hands moving the camera slightly during long exposures. The problem is more noticeable in low-light situations, but it is easily overcome by using a tripod to hold the camera steady while the shutter is open. Always use at least 1/125-second and 1/250-second exposures when using long telephoto lenses.

BRACKETING
Used by professional photographers, bracketing is an insurance against uncertain exposure conditions. Instead of gambling on the success or otherwise of a single frame, several versions of the image are taken from the same viewpoint, each with a different exposure variation. After processing, the best frame for printing or reproduction can be selected.

BURNING
A processing technique in which specific areas of the image are made lighter, for artistic effect.

BURST RATE

The speed at which a camera can save and store image data, then ready itself to capture the next shot. In recent DSLRs, this is usually no longer a problem, but some older DSLRs are unable to shoot more than a few frames in rapid succession before pausing to process the data. This can cause problems when attempting to shoot sequences of moving subjects.

CALIBRATION

The process of matching the characteristics or behavior of a device to a standard to ensure accuracy.

CARD READER

A small device used to transfer memory card data to a computer. This kind of device is essential if your camera's image-upload software is incompatible with an older computer, or when faster data-transfer is desired from a camera, which has a slower serial port connector. Look for a dual-format card reader which will accept more than one type of card to cover all the cameras you may own.

CC FILTER

Color-correction filter. In film-based photography, color-correction filters can be used to match lighting color temperature with film stock. In digital photography, this function is generally carried out by the White Balance (WB) button.

CCD

Charge Coupled Device. This is one type of light-sensitive sensor used in place of film in a digital camera. A CCD is like a honeycomb of tiny individual cells, with each one creating an individual pixel.

CF CARD

CompactFlash memory card. A small removable card which can store up to one or more gigabytes of data, depending on the card's capacity. Photo-labs often accept these for running out prints.

CD-R

Compact Disc Recordable. CDs have for a long time been the most cost-effective kind of storage media used in digital photography, storing up to about 700MB of data at very little expense per disc. Most new computers include an integral CD "burner" for writing data to the discs, which can then be read by any CD-ROM player. Older computers often require the use of an inexpensive external CD burner. CDs' are now increasingly overlooked as storage media since recordable DVDs have become more affordable. New high-capacity Blu-Ray DVDs are likely to dominate eventually.

CMOS (SENSOR)

Complementary Metal Oxide Semiconductor, an alternative type of photosensor to the CCD (Charge Coupled Device).

CMYK

Cyan, Magenta, Yellow, and Black is an image mode used to prepare digital photographs for commercial lithographic printing. All magazines and books are printed with CMYK inks, which have a smaller color gamut (range) than the RGB image mode used on computer monitors. In CMYK, "K" is short for "key plate", which carries the black ink, although it has become regarded as short for Black to avoid confusion with Blue.

COLOR CASTS

Color casts are unexpected tints that appear on your photographs. Casts are generally caused by shooting under an artificial light source such as domestic lightbulbs, or florescent tubes, without flash. Digital cameras have a built-in filtering system called the White Balance (WB) function, which compensates for the problem and adjusts the image once you have provided it with a white reference.

COLOR SPACE

In digital photography, different image modes such as RGB, CMYK, and LAB are designed with different color characteristics, called the color space. LAB is the largest color space, with RGB next, followed by the much smaller CMYK space. When converting images from a larger space to a smaller space, loss of original color can occur.

COLOR TEMPERATURE

An exact measurement of light color, expressed in the Kelvin (k) scale.

GLOSSARY

COMA
An optical defect that degenerates the image-forming ability of a lens at the edge of the image space.

COMPRESSION
Crunching digital data into smaller files. Without physically reducing the pixel dimensions of an image, compression routines devise compromise color recipes for a larger group of pixels, rather than individual ones. JPEG is a commonly used compression routine.

CROPPING
Images can be recomposed after shooting by a process called cropping. Digital photographers can use the crop tool in Photoshop and other image-editing software packages to remove unwanted pixels.

CRT SCREEN
Cathode Ray Tube, the standard type of computer monitor now being increasingly replaced by flat plasma screens and LCD technologies.

DEPTH OF FIELD
The zone of sharpness set between the nearest and furthest parts of a scene. It is controlled by two factors: your position relative to the subject, and the aperture value selected on your lens. Higher f-numbers, such as f/22, create a greater depth of field than lower numbers, such as f/2.8.

DIGITAL
In computerized devices, the method of storing and processing data as strings of binary code (ones and zeroes), millions of times per second in fast processors. In computer code, one represents "on" (or "voltage"), and zero represents "off" (or "no voltage"). 16-bit systems store data in binary sequences that are 16 characters long, 24-bit systems use sequences that are 24 characters long, and so on. The longer the binary word (the sequence of ones and zeroes), the more information can be stored in it.

DSLR
Digital Single Lens Reflex (camera). Also see Digital; SLR.

DODGING
Also called holding back, dodging is a darkroom term for limiting exposure in small areas of a darkroom print. The technique can be imitated digitally using Photoshop and other image-editing packages.

DPS
Digital Pixel (or Photo) Sensor, the general description of the different types of light-gathering sensors used by digital cameras in place of film.

DVD
Digital Versatile (or Video) Disk. High-capacity disks used to store and distribute movies digitally. The recordable version, DVD-R, is used by photographers to store their work.

EXPOSURE
The amount of light that falls onto a digital sensor, or light-sensitive material. In both photographic printing and shooting, exposure is controlled by a combination of time and aperture setting. The term is also commonly used to describe a single frame or shot taken.

FILTERS
In all photography, glass, plastic, or gelatin filters can be attached to a camera lens for adding different creative effects to a photograph. Filters work by absorbing or allowing through different wavelengths of light, thereby enabling some colors to pass through to the film while others are prevented from doing so.

FIREWIRE
A high-speed protocol and computer connection for transferring large amounts of data quickly between two devices, such as a digital camera and a computer.

FLASH
Electronic flash is calibrated to produce light of a consistent and neutral color. Flash is created when an electrical current passes through a tiny, gas-filled tube, which produces a rapid burst of light. Unlike continuous light, the light quality from a flash can't be seen before the moment of exposure.

F-NUMBERS
Aperture values are described in f-numbers, such as f/2.8 and f/16. Smaller f-numbers let more light onto your film or digital sensor, and bigger numbers, less light.

FPS
Frames per Second. The number of images that can be recorded by a digital camera within a one-second period.

GAMUT
Gamut is a description of the range of a color palette used for the creation, display, or output of a digital image. Unexpected printouts often occur after CMYK mode images are prepared on RGB monitors and are said to be "out of gamut".

GIGABYTE (GB)
One gigabyte = one thousand megabytes. See Megabytes.

GIF
Graphics Interchange Format. A universal image format designed for monitor and network use only. Not suitable for saving photographic images due to the 256-color, 8-bit palette.

GRAIN
The gritty texture visible in enlargements made from fast film negatives. In digital photography, grain does not exist, although some see it as a desirable artifact of film photography.

GRAYSCALE
In digital imaging, the grayscale mode is used to create and save black-and-white images. In a standard 8-bit grayscale there are 256 steps from black to white, just enough to prevent banding visible to the human eye.

HDD
The hard disk drive on a computer that serves as a computer's filing cabinet, also known simply as the hard disk.

HIGH RESOLUTION
High-resolution images are generally captured with many millions of pixels and are used to make high-quality printouts. Many pixels make a better job of recording fine detail compared to fewer. High-resolution images can demand lots of storage space and need a computer with a fast processor to cope.

HISTOGRAM
A graphic representation of tonal range in an image.

HYPERFOCAL DISTANCE
The focus setting used to give maximum depth of field.

INK-JET PRINTER
A versatile output device used in digital imaging, which works by spraying fine droplets of ink onto media.

INTERPOLATION
All digital images can be enlarged by introducing new pixels to the bitmap grid. Called interpolation, images that have gone through this process never have the same sharp qualities or color accuracy as original non-interpolated images.

ISO / ISO-E
International Standards Organization. The ISO standard describes film and DPS speed. In film photography, the ISO value describes a film's ability to work under low or bright light conditions. For example, ISO 100 is a slow film suitable for the brightest light situations, ISO 200 and 400 are general-purpose films, while ISO 800, 1600, and above are for shooting in lowest light conditions. Digital cameras use the same system to describe ISO equivalency (ISO-E). Just like aperture and shutter speed scales, the doubling or halving of an ISO value halves and doubles the amount of light needed to make a successful exposure.

GLOSSARY

JPEG
An acronym for Joint Photographic Experts Group. JPEG files are a universal format used for compressing digital images. Most digital cameras save images as JPEG files to make more efficient use of limited capacity memory cards. The JPEG format is known as a "lossy" compression method as image quality deteriorates after resaving.

MACRO
Macro is a term used to describe close-up photography. The lens itself determines how close you can focus and not all cameras are fitted with macro lenses as standard. Many mid-range zoom lenses offer an additional macro function, but much better results are gained by using specially designed macro lenses. When close focusing, effective depth of field shrinks to a matter of centimetres even when using narrow apertures like f/22.

MEGABYTE (MB)
Units of memory or hard disk space on a computer.

MEGAPIXEL
A measurement of the maximum bitmap size a digital camera can create. A bitmap image measuring 1800x1200 pixels contains 2.1 million pixels (1800x1200=2.1 million), the maximum capture size of a 2.1 Megapixel camera. The higher the megapixel number, the bigger and better quality print out you can make.

NOISE
Similar to visible grain in conventional photographic film, digital noise occurs when shooting in low-light conditions or when a CCD sensor is used at a high ISO setting. When too little light falls onto the sensor, pixels are made in error. Most often red or green, these randomly arranged pixels are called noise and are found in dark and shadow areas of your photographs. Noise can be reduced—and added—in most image-editing packages, using a special filter.

OPENING UP
A traditional photographic term that describes the act of setting a wider lens aperture, thereby opening the lens to allow more light to pass through to the sensor. Opening up is the opposite of stopping down.

OVEREXPOSURE
This occurs when too much light is passed onto your light-sensitive material or digital sensor due to a miscalculated exposure. The result is pale images with washed-out colors.

PERIPHERAL
An add-on to a computer, such as a scanner, printer, etc.

PHOTODIODE
One of millions of light-sensitive cells in an electronic digital pixel sensor (DPS).

PHOTOSHOP
The industry-standard image-editing software program, made by Adobe.

PIXEL
Short for "picture element", a pixel is the building block of a digital image like a single tile in a mosaic. Pixels are square in shape and arranged in a grid-like matrix called a bitmap.

RAM
Random Access Memory. This is the computer component that holds data during work in progress. Computers with little RAM will process images slowly as data is written to the slower hard drive. Extra RAM is easy to install.

RAW
A type of uncompressed picture file format that takes data directly off the digital sensor and stores it. Each make of camera will have its own proprietary RAW format.

RED EYE
Red eye is a familiar error caused when on-camera flash is used to photograph people at close range. Red eye occurs when flash bounces back off the retina and onto the film. Most cameras have a red-eye reduction mode, which works by firing a tiny pre-flash in order to close down your subject's irises.

SCANNER
A scanner is a tool for converting photographic film and prints into digital files, which can then be used on a computer. Flatbed scanners are shaped like small photocopiers and are used for capturing flat artwork by reflective light.

SHUTTER
All cameras are fitted with a shutter, either a thin curtain or series of blades that open and close to let light onto your film or digital sensor. Fast shutter speeds are used to capture fast-moving sports or action subjects, whereas slower shutter speeds are used to create deliberate blur or during very low light levels with a tripod.

SHUTTER-PRIORITY (MODE)
Automatic exposure mode, where the user sets the shutter speed and the camera automatically sets the appropriate aperture for correct exposure—also known as shutter priority auto exposure.

SHUTTER RELEASE
The button you click to make an exposure, on DSLRs situated on the top right of the camera body.

SLR
Single lens reflex camera, a camera designed to let the photographer compose directly through the lens. This is possible thanks to a series of mirrors called a pentaprism, which presents a corrected scene to your viewfinder. The pentaprism gives a more accurate tool for precise composing compared to range finder viewers.

SMARTMEDIA CARDS
A variety of small, removable memory cards, on which can be stored varying amounts of data. Depending on the capacity of the card, this can range from 1GB to as much as 128GB.

STOP
A common term used to describe a single shift of exposure along the aperture or shutter speed scale. When an exposure of f/8 at 1/60th of a second is changed to f/5.6 at 1/60th of a second, the result is an increase by one stop. Smaller shifts such as half or one-third of a stop can be set by using the exposure compensation dial.

STOPPING DOWN
The process of setting a smaller aperture to prevent excessive light from passing onto the sensor. The term derives from traditional lenses, where aperture scales were presented as click stops on the lens barrel.

TIFF
Tagged Image File Format, the most common cross-platform image format. Compressed TIFFs use a lossless routine to retain image data.

TTL METERING
Through-the-lens metering. Modern cameras use TTL metering for precise light measurements by reading the actual level of light that passes through the lens, rather than measuring the light levels outside it.

UNDEREXPOSURE
When not enough light reaches the sensor, underexposure occurs, creating images that look washed out.

USB
Universal Serial Bus, a common protocol and computer connection for sharing data quickly between compatible devices.

WHITE BALANCE (WB)
A camera setting that overcomes color shifts caused by the different color temperatures of light.

INDEX

ACKNOWLEDGMENTS

Writing and publishing a book is no easy task. *Mastering Your Digital SLR* exists due to the combined efforts of many people, some of whom I mention here, all of whom I thank sincerely.

To the people who helped me in the field, including Stu Porter, West Mathewson and Riaan de Villiers. To those who helped behind the scenes, including April Sankey, Luke Herriott, Chris Middleton, and the rest of the team at RotoVision. To those who posed in front of the camera, including my young son who, no doubt, will not thank me when he's old enough to understand! And finally, to my family at home, because they are the ones who have to put up with me when I'm up against a deadline.

I would also like to thank Paul Harcourt Davies of Hidden Worlds Photography.

Additional image credits
Shutterstock: 6 (bl), 11 (bl), 12 (tr), 35, 86-87, 127, 131, 152-153, 162-163, 164-165
Thinkstock: 51, 60 (tr), 61, 75, 90, 96, 104, 111, 113, 128, 136, 166-167, 170-171
Tony Seddon: 98-99, 132, 138, 148, 150, 156, 158
Jason Keith: 17, 36-37, 42-43, 82 (tr), 95

All equipment images appear courtesy of the manufacturers.